SUNKEN KLONDIKE GOLD

How a lost fortune inspired an ambitious effort to raise the *S.S. Islander*

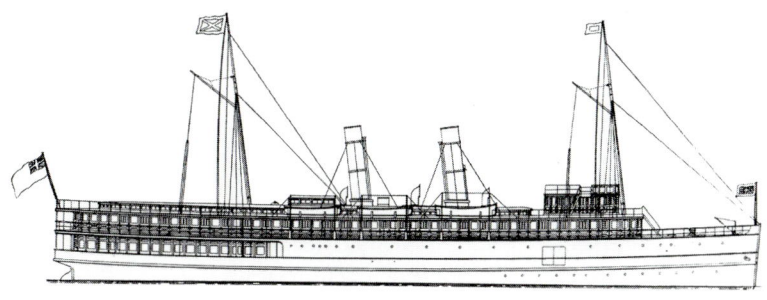

Leonard H. Delano

Copyright 2011 Delano Publishing

All rights, including that of the translation into other languages, reserved. No part of this book may be reproduced or transmitted in any form or by any means, electronic or mechanical, including photocopy, recording, or any other information or retrieval system, without permission in writing form the publisher.

Cover and Interior Design: Anita Jones, Another Jones Graphics
Editor: Sue Mann, Working with Words
Proofreader: Diane Johnson
Indexer: Sherrill Carlson
Printing Broker: Bob Smith, BookPrinters Network
Distribution: Aftershocks Media/Epicenter Press

COVER PHOTOGRAPHS (all photos were taken by Leonard H. Delano unless otherwise credited): Front—top, left, Charley Hayes gets ready to go down in a diving bell that workers called "The Thing"; middle, left, workmen pose on the huge propeller that once drove the *S.S. Islander;* bottom, left, a physician visiting the salvage site from Juneau examines the skulls of a human and a dog recovered from the wreck; above, the *S.S. Islander* hulk sits on the beach at Green Cove stern first between the *Griffin* (left) and the *Forest Pride;* Back—top, the *S.S. Islander* leaves Victoria for Skagway and the Klondike, July 1897, Image A-00561 courtesy of Royal BC Museum, BC Archives; bottom, the author moves coal salvaged from the *S.S. Islander* to fire a steam pump for sluicing operations.

ISBN 13: 978-1-4507-3660-2
Library of Congress Control Number: 2010942327

Printed in the USA

Dedication

To Leonard:
Your dream of publishing your account of the Islander's *raising is finally realized.*

To Emily:
For more than 50 years Leonard's wife, business partner, and helpmate,
you used an old manual typewriter to type and retype this manuscript.

Recovered Carpenter's Plane

Contents

Acknowledgments		vii
Prologue		viii
One	The Irvings, the Canadian Pacific Navigation Company, and the *Islander*	1
Two	Skagway Departure	9
Three	The Stowaways	15
Four	The Sinking	17
Five	To Raise the *Islander*	31
Six	Getting the Act Together	39
Seven	Underway	49
Eight	Grappling in the Dark	59
Nine	On a Toot	71
Ten	Hooking the Big Fish	79
Eleven	Big Lifts	91
Twelve	Demise of a Friend	107
Thirteen	The Second Year	109
Fourteen	Up from the Deep	129
Fifteen	The *Islander* Is Up!	137
Epilogue		160
Glossary		163
Index		164
About the Author		166

Recovered Nameplate

Acknowledgments

Chapter One: Information from the Provincial Archives, Victoria, B.C., and from *The Princess Story: A Century and a Half of West Coast Shipping* (Norman Hacking and W. Kaye Lamb; Mitchell Press Ltd., Vancouver, B.C.).

Chapter Four: Information from the Provincial Archives, Victoria, B.C.; Vancouver B.C. Archives; and the *Victoria Times* and Vancouver *Province*.

Our thanks to the Provincial Archives, Victoria, B.C. for the use of photos.

Unless otherwise noted, all photographs are by the author.

Prologue

If you travel to southeastern Alaska by water, your route will likely include Stephens Passage, a part of the Inside Passage between Skagway and Juneau. Here on August 15, 1901, the sinking of a favorite passenger vessel, the SS Islander, during the last of the Klondike gold rush was an event still echoing down the years in the annals of North Pacific marine history.

If the opportunity permits, you can see Point Hilda, a southerly projection of Douglas Island approximately 12 miles from the capital city of Juneau. Just north of the Point, the Passage joins a straight stretch of water called Lynn Canal.

Here in the hours between an Alaskan summer midnight and dawn, the Islander, with 176 passengers and crew, stove a mortal gash in her port bow and plunged through 350 feet of water to the bottom. The ship sank in less than 20 minutes, leaving many to struggle in the cold water under spreading swirls of fog, the occasional cries for help breaking the silence of the pristine surroundings.

Across the Passage to Admiralty Island is Green Cove. Here the raised Islander's remains were beached almost 33 years later in a saga of deep water recovery that set a world's record at the time. The two-year salvage struggle was unique, for lifting a ship from that depth and beaching her was accomplished prior to the days of more sophisticated equipment.

Still below in 50 fathoms of water is the bow of the Islander, broken off from the rest of the steel hull during the salvage lifts. Entombed are the bones of some of the 11 stowaways—unlisted on the passenger record and anonymous.

Prologue

Time has dimmed the story and many casualties have swept across its pages since the sinking and salvaging, but the story is still an unusual one of the North Pacific. Compared with more recent deep sea explorations such as the *Titanic* or the recovery of older ships such as the *Vasa*, the *Islander* salvaging was an exercise with more basic tools and methods. From the manually operated lift winches to the use of the adze and the axe in trimming logs for the final lift truss, manpower and the tides were the major factors in the recovery. Marine salvaging is a struggle against the sea; this salvage, and the clutch of the deep, was one to remember.

The writer, a member of the salvage crew, desires to record it without fictionalizing. Though the hour is late and most of the crew are no longer with us, references to precious log books with their daily on-the-job records of circumstances and progress help relive the bad days and the good days of the salvage efforts.

——Leonard H. Delano, 1987

My father, Leonard H. Delano, was part of the salvage crew for several reasons: He had no money to continue his studies at the University of Oregon, he had no job, the United States was only starting to recover from the Great Depression, and he always had a huge curiosity about Alaska. Being part of the salvage crew gave him the chance to earn a little money and use his photographic ability. My brother, Leonard Delano Jr., and I listened to the many stories of Dad's Alaska adventure and encouraged him to write about those events.

——Doug Delano, 2010

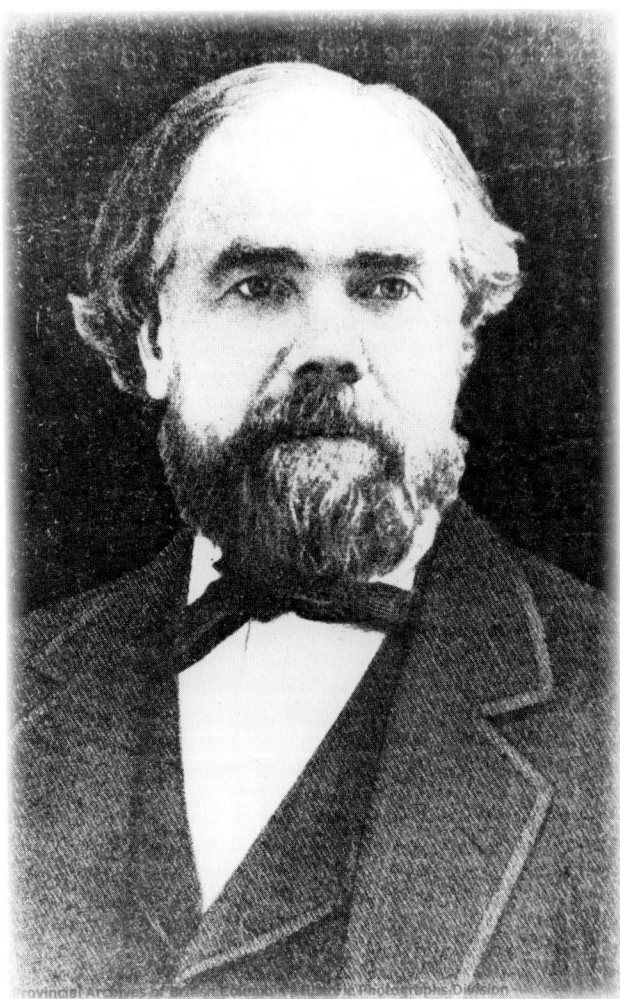

Captain William Irving.
Image G-01924 courtesy of Royal BC Museum, BC Archives

Chapter One

The Irvings, The Canadian Pacific Navigation Company, and the *Islander*

To tell the story of the *Islander* is to tell the story of the Irvings. As a boy in Dumfrieshire, Scotland, once the home of Robert Burns and Thomas Carlyle, William Irving had seen many young Scots leave for life aboard ships. In the late 1820s, he decided it was to be his life also, and at 13 he became a cabin boy.

Advancing to first mate at 19 and master at 29, by the age of 33 he was part owner of the barkentine *Success*, which sailed from Boston and rounded the Horn for California. The year was 1849, and the Gold Rush up the Sacramento River was on. Unloading his cargo as consigned, he was approached by a surveyor from the village of San Francisco who had learned he was heading for Oregon. "Carry this plat personally and file it for me at Oregon City," he told Irving. Oregon City was then the first incorporated city west of the Rocky Mountains, and the original plat of San Francisco is still there.

A boom in transportation between California and Oregon prompted Irving to stay in nearby Portland, where he developed a riverboat operation in addition to some coastal trade. Oregon's agricultural goods and lumber were needed in California. Irving had landed in the area at the right time and he took advantage of it. Portland was the focal point of nature's ready-made transportation routes: the Columbia and Willamette Rivers.

Captain Irving was now married to Jane Dixon, from Andrew County, Missouri, and they filed a donation land claim on what is now Portland's central east side. Their first house, a log cabin, was at a point that later became East Broadway and Crosby Streets, and the neighborhood northeast of it later became known as Irvington. Here in 1852, in a redwood-exterior house that replaced the log cabin, a son, John, was born. John

WILLIAM IRVING HOUSE, NEW WESTMINSTER, VANCOUVER, B.C. NOW A MUSEUM AND HISTORICAL SITE. (SITE OF JOHN IRVING HOUSE IN VICTORIA, B.C. IS NOW THE CITY'S JOHN IRVING PARK.)

was to become the heir to his father's business and principal in the story of the *Islander*.

Gold, the catalyst for action and a magnet for men, once again was changing the course of the Irving family. In 1858 the new frontier of British Columbia was experiencing a gold rush in the Fraser River country, and the gold fields in the Caribou were attracting thousands. Like the California rush, it was creating a tremendous demand for transportation facilities, this time mainly on the rivers.

Leaving his riverboat interests in the hands of his brother-in-law, George W. Shaver, who was to develop the successful Shaver Transportation Company, in 1858 Irving left for Vancouver, B.C. His son, John, was then four

years old. From his headquarters and home in New Westminster, a satellite community of Vancouver, Irving expanded a riverboat fleet on the Fraser and other nearby waterways. Competition was stiff, with the gold rush attracting aggressive river men into the new country where fighting was necessary to hold your own. One of his principal competitors was Hudson's Bay Company, whose vessels were later to be combined with the Irving Pioneer Line under Captain John Irving.

William Irving was a highly regarded citizen of both his community and on the river. He died on August 28, 1872, at age 56 of what was said to be a combination of pneumonia and smallpox. Young John had been gaining experience on his father's boats since the age of 12, and at 16 he had acted as skipper. At 17 he had been given command of the company's new number-one boat, the *Onward*. He was 20 when his father died, and he assumed responsibility for the firm.

Norman Hacking and W. Kaye Lamb, in their *Princess Story*, refer to him as follows: "He was self confident and his naturally reckless disposition prompted him to take risks where other men would hesitate." For instance, for many years he refused to insure his ships, a costly decision because he had his share of hard luck; however, he became a proven and popular pilot on the Fraser, Stikine, Thompson, and, later, Yukon Rivers. For 30 years he remained a generous and popular figure in the marine field. His Pioneer Line fleet was expanded under his direction, with other capable and older men supporting his organization. When the $50,000 steamer *Elizabeth Irving* was destroyed by fire on her second trip, she was replaced by construction of the R.P. *Rithet*. The *Rithet*, named after his merchant brother-in-law, was said to be the largest and finest of the sternwheelers on the British Columbia coast at the time.

In 1883 the Canadian Pacific Navigation Company (CPN) was formed through the combination of the Irving Pioneer Line and the Hudson's Bay Line, with John Irving at the head. That year also saw his marriage to Jan Munro, daughter of the late chief factor of the Hudson's Bay Company. His marriage made Irving the

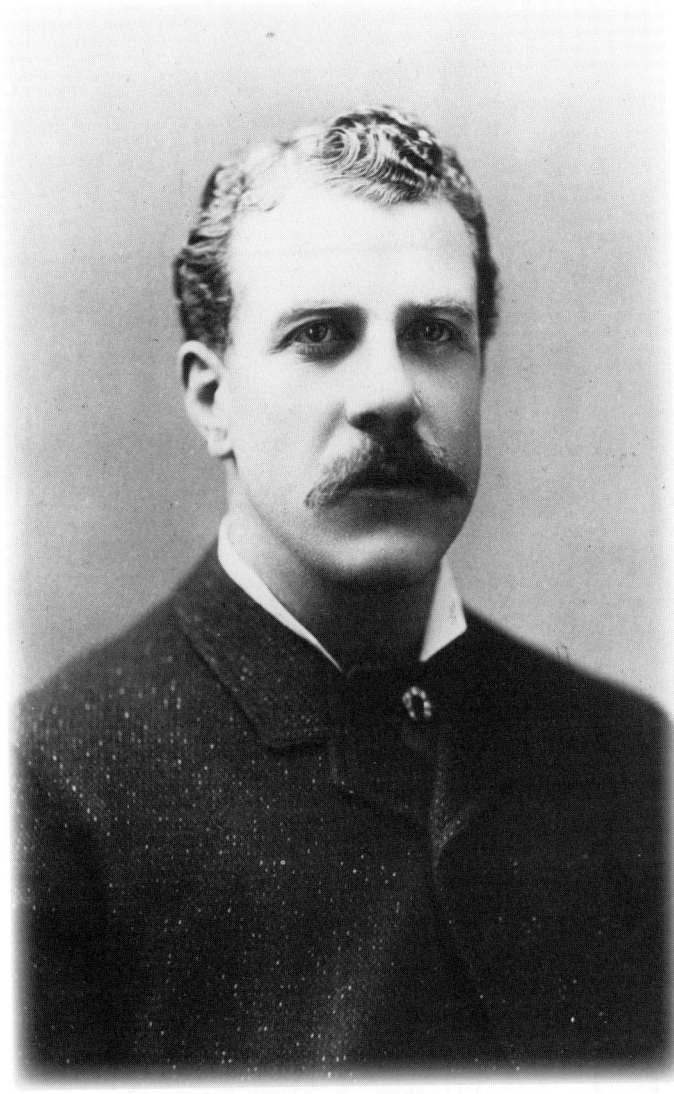

CAPTAIN JOHN IRVING.
IMAGE A-01740 COURTESY OF
ROYAL BC MUSEUM, BC ARCHIVES

brother-in-law to Rithet, who was married to the other Munro daughter.

In 1887 Irving ordered the construction of the *Islander* with an eye toward advancing the CPN's coastal shipping business. The *Islander*, planned to be queen of them all in the North Pacific waters, was built by Napier, Shanks and Bell, a well-regarded shipbuilder of Glasgow, Scotland. Napier had been the contractor for the first Cunard liners.

Design was for a fast ship of 240 feet long, a 42-foot beam, and 14 feet depth-of-hold. Power was in two compound triple expansion engines built by Dunsmuir and Jackson of Glasgow, with a total of 5000 horsepower. Tonnage was 1495 gross and 478 net. Irving had Captain George Robertson of the Cunard Line supervise her construction and take command of her maiden voyage to Victoria. She was finished pretty much on schedule and was launched on the Clyde River in the summer of 1888. The Glasgow *Daily Mail* reported that the *Islander* was christened by Miss Harvey, granddaughter of Hon. Robert Dunsmuir, president of the Executive Council of British Columbia. Mr. Napier toasted to the success of the *Islander* and the health of Miss Harvey.

On September 22, 1888, the *Islander* sailed from the Tail of

CHAPTER ONE

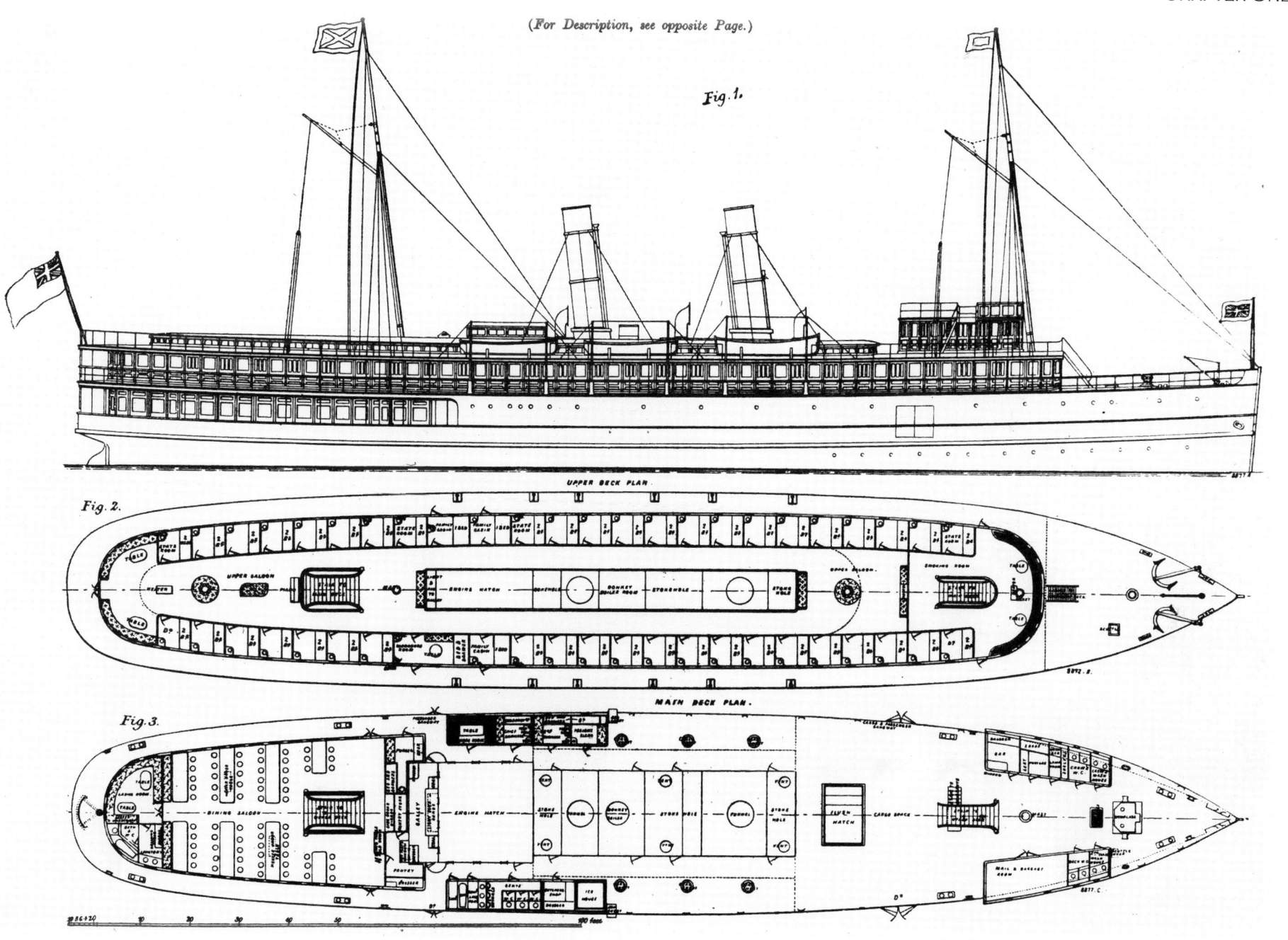

S.S. ISLANDER DECK PLANS AND PROFILE. COURTESY OF ENGINEERING, LONDON

5

the Bank and arrived in Victoria, B.C., on December 9. Robertson was in command; J.T. Walbran was chief officer. Walbran was later the author of the book, *British Columbia Coast Names*.

The *Islander* proved her speed as the fastest ship on the North Pacific coast and the most luxurious in her area, if not the entire coast at the time. She had glass panels in her well-supplied dining saloon, with scenes from the Canadian Rockies. Photos of the dining area and other interior views bore out the claims of her publicity reviews. On a trial run in Scotland she had averaged 12.2 knots, but her engines, once broken in, gave her 15 knots.

Her first run was Vancouver-Victoria on Sunday, December 30, 1888; her captain was George Rudlin. A new, high standard was set by her dining room, which was on the European plan. Passengers ordered from a bill of fare instead of the prevailing practice of one kind of serving only.

Passenger service was extended to the Puget Sound and then to the northern B.C. coast. In 1892 southeastern Alaskan points were served, first during the cannery season and then on advertised tours.

During her career on the B.C. coast, the *Islander* was usually commanded by Captain Redline on the Vancouver-Victoria run and Captain John Irving on the northern route. Captain William Meyer took command on the northern route in the summer of 1898, Captain Josiah Goss in the summer of 1900, and Captain H.R. Foote during her last days in 1901.

Records show that business was good at the start of her operation and her owners showed a profit. During the depression years of the early 1890s the opposite was true; when the occasion demanded she was put to use in capacities other than as a luxury steamer.

As an interesting example of the latter, in 1894 she paid a visit to the harbor of Portland. It followed a previous visit by the CPN steamer *Danube* on May 3, 1893, with an overloaded cargo of Asian immigrants—612 Chinese and 21 Japanese. They were brought from the Orient on the Canadian Pacific Empress Line and transshipped at $6 a head to Portland for a local Chinese contractor. But the Portland

customs and immigration officials and the police acted on a warrant from the U.S. Department of Justice, and penalties were exacted on the ship's captain.

Captain Irving hurried down from Victoria and put up a bond for the ship, but the resulting unloading of the Chinese was too slow to suit him. After only 202 had been allowed to land, he ordered the gangplank pulled up and he steamed down the Columbia River, bypassing an officer at Astoria armed with writs of habeas corpus. But about a year later and unfazed by the *Danube* experience, Captain Irving unloaded 94 Chinese and 31 Japanese in Astoria and on April 22, 1894, brought the *Islander* to Portland with 215 Chinese and 31 Japanese aboard. Then he had a repeat of the *Danube* experience and on May 4 pulled up the gangplank, headed for Astoria, and, despite several shots across his bow at Astoria, headed out to sea with 105 wailing Chinese still aboard. This was the only time, apparently, the *Islander* was in Oregon, but it was one of the many examples of Captain Irving's unorthodox actions.

If the depression of the early 1890s was tough for ship and river operators such as Irving and his company, the Klondike gold rush of 1897 and 1898 was to change that. The Victoria *Colonist* reported that in July 1897 the *Islander* was posted by the CPN for the Skagway and Dyea run from Victoria. On July 28 it was reported, "Never since the old Caribou days have such scenes been witnessed in Victoria as today when 400 miners with their supplies boarded the *Islander* for Dyea on the way to the Klondike." But the *Islander* was not large enough, and as a consequence the steamer Tees was pressed into service to take care of the overflow. The commander of the *Islander* on this trip was Captain John Irving.

The January 12, 1901, Vancouver papers reported that the CPN Co. had been purchased by the Canadian Pacific Railroad (CPR). This was the natural outcome of several changes in transportation and economic influences on the CPN. The arrival of the CPR's first transcontinental train at Port Moody from Montreal on July 4, 1886, spelled the decline of considerable riverboat traffic that came from the Fraser River area. To add to the decline of CPN's business was the increasing competition from smaller river craft. The marine

division of CPN continued under that banner for about three more years, after which the name was changed to the British Columbia Coast Service of the Canadian Pacific Railroad.

At the time of the *Islander* disaster, the CPN had been under the CPR's ownership for approximately seven months. Management and personnel were still about the same as previous ownership; however, in March 1901 Captain James Troup, also a native of Portland, replaced John Irving as manager. He was the son of Captain W.H. Troup and grandson of Captain James Turnbull, both early-day Columbia River steamboat captains. Troup was later to impose many design decisions on the CPR's Princess ships and their management. But the *Islander* could still be said to be the forerunner of the original Princess ships. At the time of the change of ownership, the *Islander* was being refitted for improved tourist trade to Alaska.

. . .

CHAPTER TWO

SKAGWAY DEPARTURE

GOLD AND EXPRESS SHIPMENTS were stowed, passengers were aboard, and steam was up, but the *Islander* lay idle at the end of the wharf, her 6:30 p.m. departure time long past. Purser Bishop pushed away the large but orderly piles of paper and rose from his cramped desk as Second Officer Powell came through the purser's office door.

Bishop grunted, "What in blazes are we waiting for now?"

"Neither the skipper nor Pilot LeBlanc is aboard," responded Powell.

The two men exchanged knowing looks. As if to affirm their thoughts, a crewman appeared at the door to report that Captain Foote had arrived in the company of some friends from a local shipping firm.

Down in the engine room the two Dunsmuir and Jackson triple expansion engines wheezed softly, crouched and ready to spring for the ship's southbound run, their steel muscles encapsuling 5000 horsepower. The second engineer read the gauges. "Ready to go when topside gets off its duff," he muttered.

The *Islander* was docked at Billy Moore's wharf in Skagway, Alaska, that afternoon of August 14, 1901. The watercraft that lined the wharf were typical of the arrivals and departures of this trim passenger vessel, the forerunner of the Princess line of ships of the Canadian Pacific's British Columbia Coast Service. Skagway, also known as Skaguay, its original Indian name, took on a holiday air with the *Islander's* presence.

This gold rush staging point and gateway to the Yukon and the Klondike was a village busting its britches in the tag end of the 19th century. Almost overwhelmed by the two flanking coastal mountains, in 1899 this tidewater community achieved the title of largest town in Alaska. The Trail of '98 had catapulted its

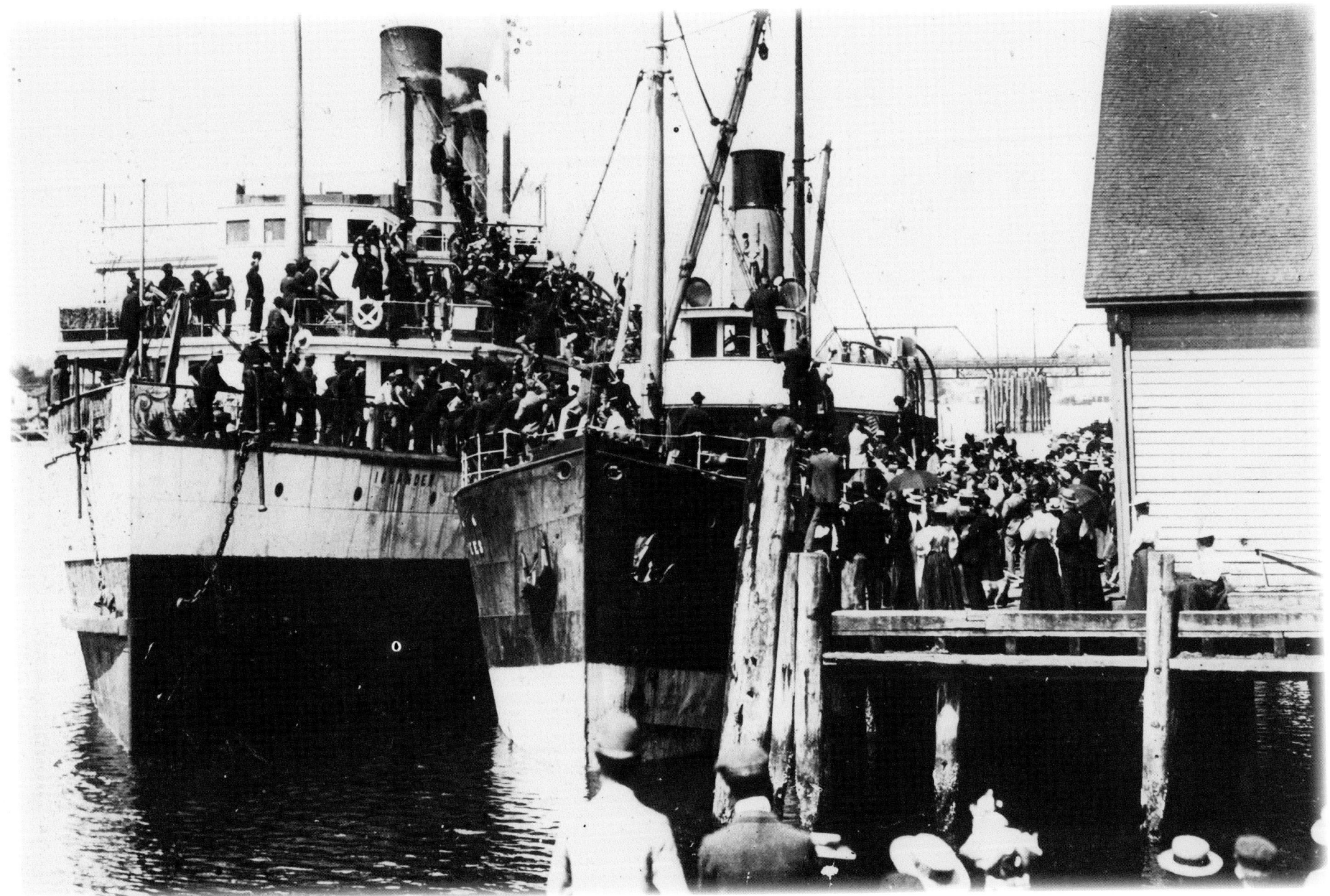

Skagway with The Islander at dock, circa 1901. Image A-00079 courtesy of Royal BC Museum, BC Archives

CHAPTER TWO

docks and waterfront to importance as a gold port. In 1900 it became an incorporated city, vying with Juneau for the honor of being the first incorporated city in Alaska.

Evidence of the gold rush was still at hand, in the late summer of 1901. The Klondike was continuing to produce gold, though the flow had diminished from its original flood. Contents of money belts and pokes were still going south, many on the persons of their owners. Some had been exchanged for bank certificates or other paper for convenience of carrying, but the original gold dust and nuggets still had to be transported south, such as the express boxes being shipped this day.

In 1898 the pack train and shank's mare of packers traversed terrible trails as well as the Chilkoot Pass. Now, in 1901, the White Pass and Yukon Railroad was carrying

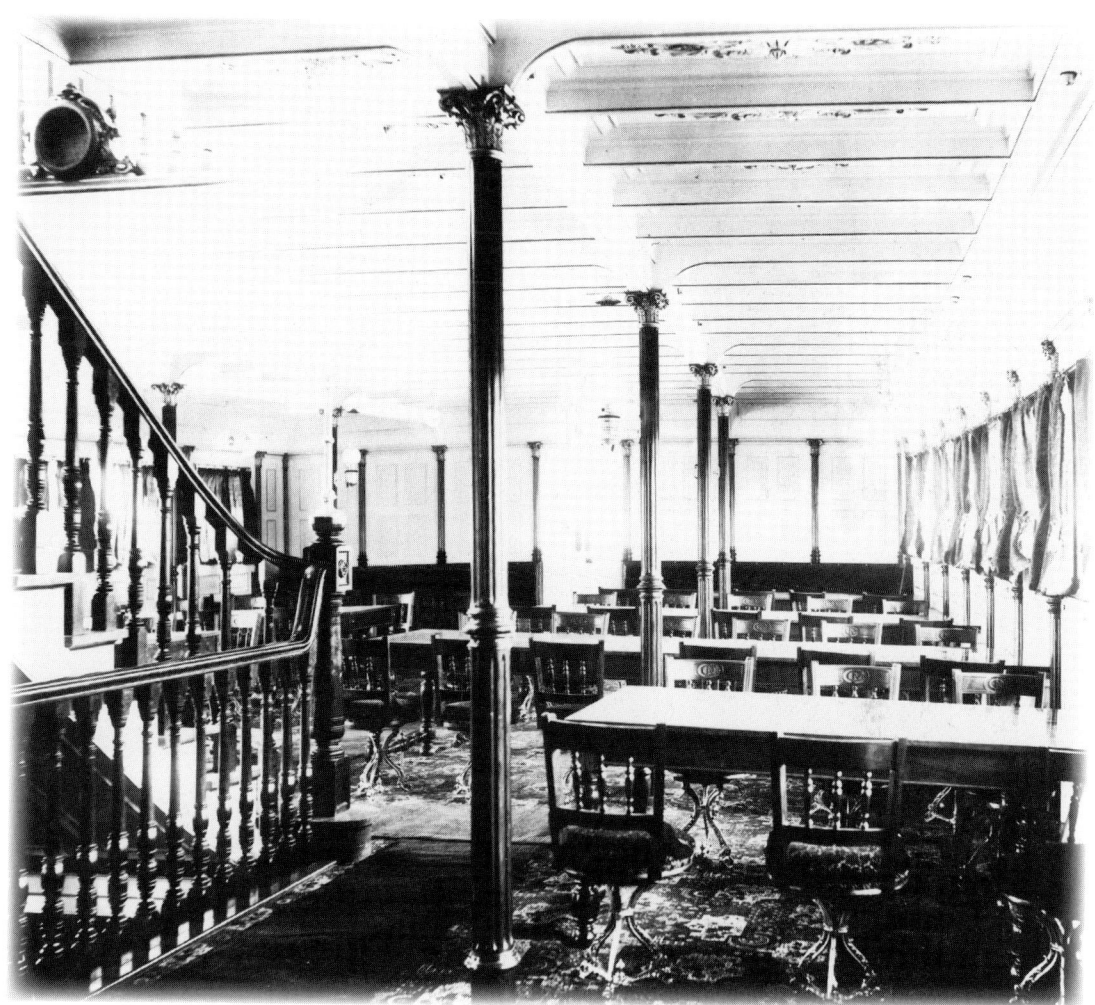

CORNER OF DINING SALOON, S.S. ISLANDER.
IMAGE B-02257 COURTESY OF ROYAL BC MUSEUM, BC ARCHIVES

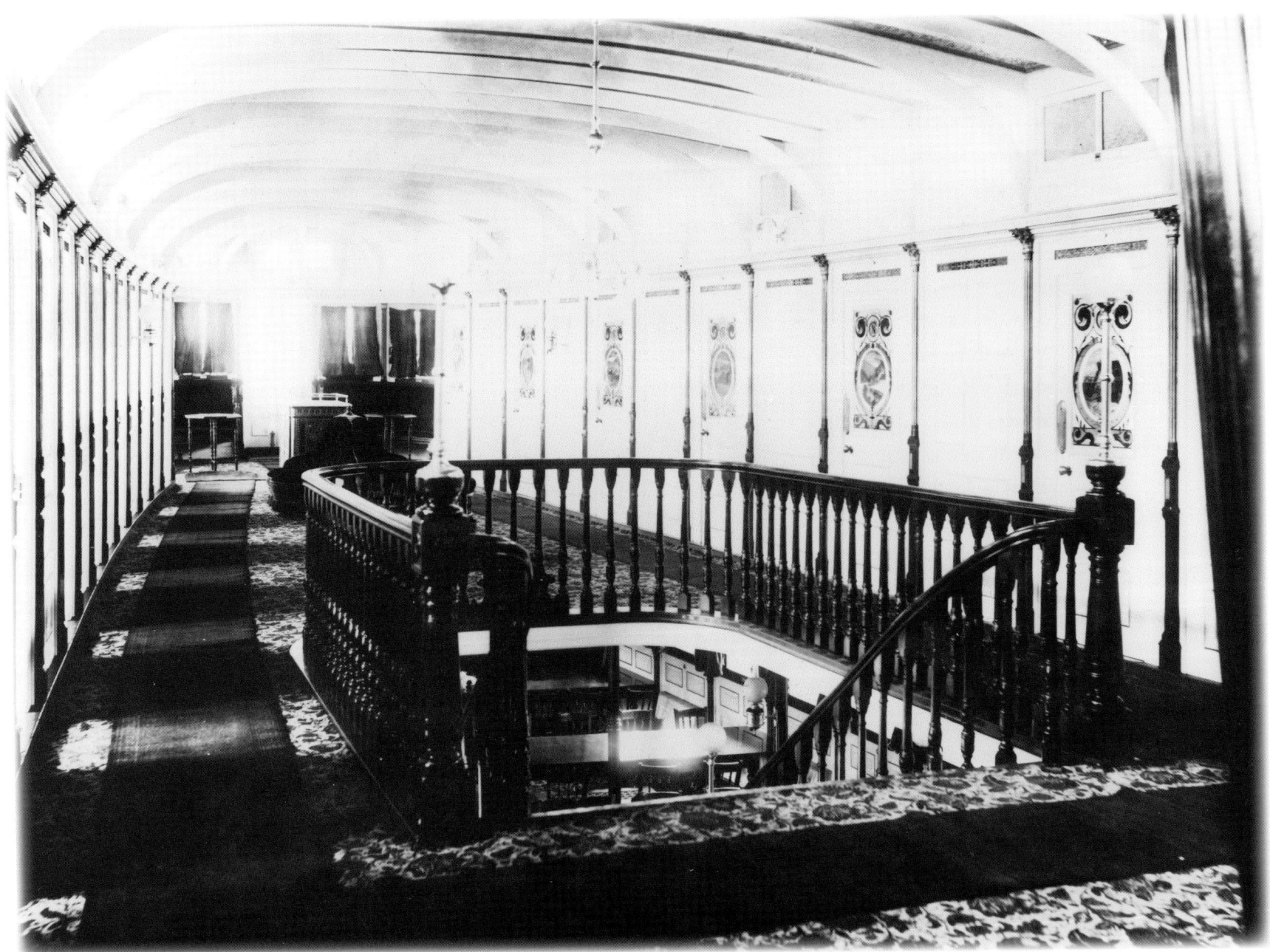

Hallway on upper deck. Image A-06316 courtesy of Royal BC Museum, BC Archives

CHAPTER TWO

freight and passengers between Whitehorse in Yukon Territory and the coast. Riverboats and steamers completed the connection to Dawson. The 10-foot-wide rail bed with narrow gauge 3-foot- spaced rails was now a reality, thanks to the explorations of a possible route by Captain Billy Moore and others, the leadership and drive of Mike Heney and his crews, and their English financiers, the Close Brothers of London. It was still rough in spots, but it was a luxury compared to the trail and a monument to men's determination and sweat.

Sheer rock cliffs had been chipped away by explosives and pick and shovel, defying most of the winter's ice and winds. The agonizing Chilkoot Pass and Trail of '98 was bypassed. The golden spike for the White Pass & Yukon Railroad had been driven at Carcross, Yukon Territory, on July 29, 1900.

And such was the contrast of the *Islander*, a luxury ship for passengers compared with earlier waterborne transportation.

On Broadway, Skagway's principal street, the railroad terminal and the dock alongside the *Islander* were indeed alive. The arrival of some from the dreary interior and the greetings and good-byes to old acquaintances gave a surge to the slowing pulse of this jump-off point for the Klondike.

Customs Inspector C.L. Andrews, who had cleared the Islander earlier in the day, was among those on the dock to see her leave. He, of all persons, may have been aware of the contents of the boxes that were trundled aboard through the freight doors at the forward end of the ship, but some eluded official eyes.

A southbound passenger surveyed the wharf from the rail of the second deck as crewmen and longshoremen brought the last of the baggage and freight aboard. He looked up at the sheer mountains, close alongside the little coast town, and at the cloud banners that had unfurled to reveal the blue sky. A southwest wind was building. One could never tell when it would rain on this strip of Alaska's panhandle as well as farther south on British Columbia's western edge. But for today the weather was fine and departure time had arrived.

Crew members and passengers had been busy preparing for the trip, unaware of the roles Fate had planned for them approximately seven hours later. Horace Fowler, assistant steward, had busied himself checking the stores on hand. Fowler, a newer employee of the company, was in his early 20s and a dedicated

member of the crew. Proud of his assignment to the company's flagship, he took his job seriously. John Irving, "father" of the *Islander* and first captain to take her to Alaska during the Klondike rush, played the role of host to the customers. The *Islander* was an example of the best in food, drink, and fellowship in its dining saloon and bar as it plied its route in British Columbia and the Alaskan and Puget Sound waters. Stewards aboard were busy crewmen, and Fowler expected a busy southbound trip.

Hours later, Fowler was to play a heroic part in the drama in Stephens Passage.

. . .

THE **ISLANDER** LEAVES VICTORIA FOR SKAGWAY AND THE KLONDIKE, JULY 1897. SMALLER STEAMER TEES ON RIGHT ALSO MAKING READY TO DEPART. IMAGE A-00561 COURTESY OF ROYAL BC MUSEUM, BC ARCHIVES

Chapter Three

The Stowaways

The fo'c'sle of a ship in days of sail was typically the preserve of the crew, but it had been changed somewhat on the *Islander*. Baggage rooms were provided on the starboard side forward, and some crews' quarters were adjacent to these rooms below decks. In providing for extra coal bunkers, space had been used in the forward section, and an opening for a bulkhead door allowed for transfer of coal to the boiler room.

Apparently, it was an open secret that a benevolent policy allowed some down-and-out and would-be sourdoughs to travel without charge below decks if they could unofficially work their way. Traveling conditions in or adjacent to the coal bunkers were not ideal, but the price was right for the transportation. Revelations at the official inquiry in Victoria later recorded that 11 stowaways had been aboard when the *Islander* sailed, although their number was never included in the casualty list. Who they were is not recorded either, but comments of some who had been in Skagway at the time give an idea of their backgrounds. I use assumed first names for convenience.

Andy had intended to go on to Dawson City but ran out of money and supplies before attempting the climb over the Chilkoot Pass; as a minimum the Mounties required approximately a ton of gear and food before crossing the border into Canada at the top of that dreaded pass. Andy obtained a job in Skagway helping a packer and later worked part-time helping unload supplies at the Skagway docks. Then he got sick, and one thing led to another. He yearned to get back home.

Joe had made it to the gold fields, but after two winters in the Yukon he decided his luck had run out. What he had earned slipped through his fingers after a few sessions at the card tables. He then wisely refrained from any more such sessions until after he earned enough working for others. He bought tickets on the river steamer

and the White Pass & Yukon Railroad for a southbound trip as far as Skagway. (Thank God for the railroad!) He looked forward to a winter in Victoria again.

Bill was one who had never gotten out of Skagway. A dropout from high school in Seattle, he had made it north the year before by selling his personal things and borrowing from his folks. Odd jobs included working for John Troy, who was later destined to become governor of Alaska. Bill was general helper and deliveryman for Troy (then editor of the *Daily Alaskan*, Skagway's newspaper). Other work included doing odd jobs for "Mother" Harriett Pullen at her restaurant. But for him the thrill of coming this far north had evaporated. Rumors traveled to Skagway that the depression was subsiding in the States, or at least in Seattle, and he decided that chances for a job might not be too bad now.

Pete was an ironworker in Seattle before the depression hit. Married and with a three-year-old, in 1899 he and his wife on the spur of the moment decided she could live with her sister and brother-in-law while he went north on borrowed money to make his fortune. But while working on the White Pass & Yukon Railroad construction crew to make money for a grubstake to the gold fields, his right leg was broken by a rolling boulder and was not set correctly. Eventually he decided to head home, but passage money was a problem.

Word got around of others boarding southbound boats as stowaways. Opportunity arrived with the *Islander*; separately or in pairs these four men and seven others on the afternoon of August 14 found themselves below decks in the forward end of the *Islander* lying doggo in the corners of several bunkers.

"Reckon we'll need a good washin' when we get outa here," commented one with a knowing look at his companions.

"All I want to do is not go through another winter up north again," responded one of his companions.

And so it went. When they heard the accelerated throbbing of the engines, an exuberant cry went up. So far, so good. But they were soon silenced by a stoker who told them that coal was needed pronto. Four or five at a time worked a four-hour stretch, then they traded with those who were to take the next shift.

. . .

CHAPTER FOUR

THE SINKING

THE RECORDS SHOW THAT the night was clear in the Lynn Canal area preceding Stephens Passage, and Pilot LeBlanc on the bridge saw no reason to reduce speed. As the *Islander* continued southbound with her faithful engines sending her at a speed of 12 to 15 knots, the outline of Douglas Island became more prominent portside.

At this juncture the waters of Lynn Canal become Stephens Passage and the southbound course must be altered to a southeasterly one, hugging and paralleling Douglas Island. Shortly after entry into the Passage, along this course the steep sides of Douglas Island come out to a point and then abruptly recede. This is Point Hilda. If too much correction is made too soon, Point Hilda would be an obvious obstacle.

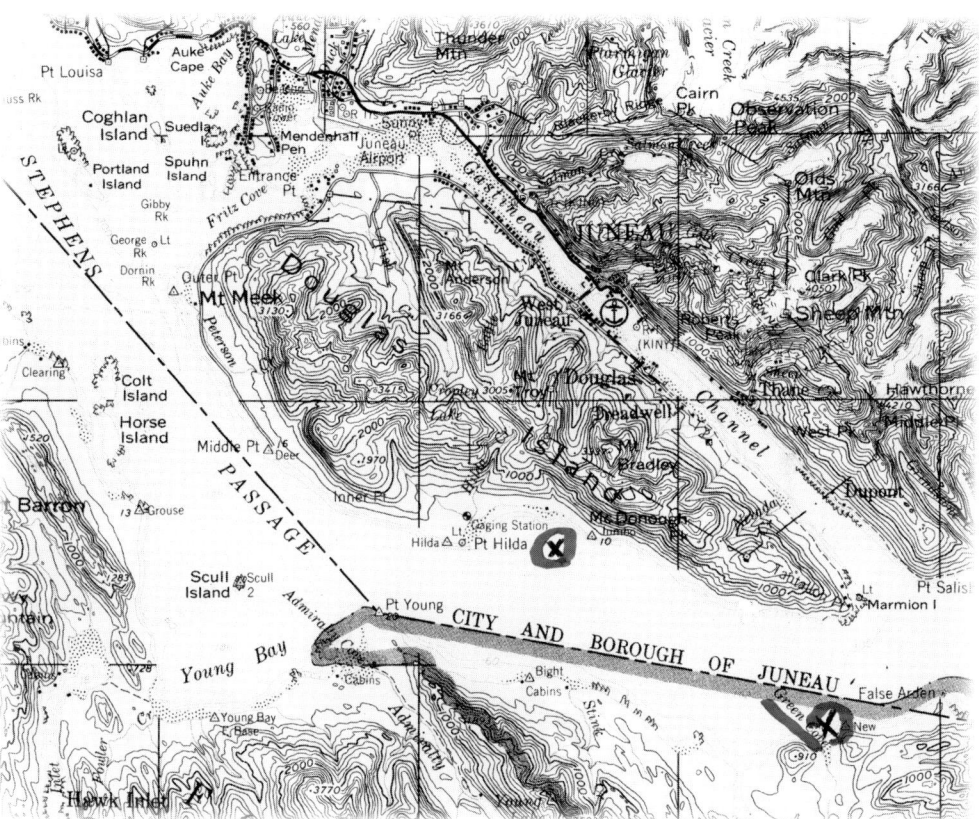

POINT HILDA AND A PORTION OF STEPHENS PASSAGE WITH GREEN COVE, ADMIRALTY ISLAND LOWER RIGHT CORNER. COURTESY UNITED STATES GEOLOGICAL SURVEY

17

Traveling in a larger arc would put a vessel more in midchannel but could add a few minutes to its travel time.

The course of the vessel in Stephens Passage was therefore determined not only by the amount of correction or change but also by the timing of the correction. LeBlanc's order to the helmsman was apparently for the standard amount of change in course; however, soon afterward at least one additional correction was necessary. Could the alteration to the southeast by east have been made too soon, which brought the ship too close to Douglas Island?

The profiles of the land masses showed plainly, but the dark surfaces of the Passage were apparently not so revealing. And ahead, typical of changing seasonal temperatures, a fog was forming close to the water in growing and spreading patches.

The night had a noticeable chill in the air and Charles Ward, watchman, pulled his coat closer about him. During testimony at the inquest in Victoria, Ward reported, "Ice on either side at a distance of probably half a mile" prior to the fatal area, but *saw no ice in the fatal area*. (These and following italics are mine.)

Quartermaster George Ferry relieved the helmsman at midnight and reported it was clear from then until about 2:15 a.m., and *he saw no ice*.

Second officer George Powell *saw no ice* when he came on deck or later when in the water.

Shortly after 2:00 a.m., with Pilot LeBlanc in command on the bridge starboard side, quartermaster Ferry in the pilot house, and Watchman Ward on deck forward, the *Islander* struck with a grinding crash on the port bow.

As LeBlanc ran to the port side, he signaled Ferry to stop engines. "In about three seconds I was looking over the port side but saw no ice," LeBlanc testified at the inquiry.

"Call the captain!" LeBlanc shouted to Ward, who had appeared for instructions. Ward was not able to find Captain Foote immediately, so he pounded on the cabin door of Neroutsos, the first officer. "Starboard your helm!" LeBlanc ordered Ferry. This would presumably give more clearance to the obstruction they had hit on the port side and head more for midchannel.

Neroutsos met the captain on the bridge a few minutes later and recommended heading for the closest land—Douglas Island. Foote, knowing the steepness of the Douglas Island shore nearby, rejected the idea and opted for the sloping beaches of Admiralty Island across the channel.

Calling down the speaking tube to Chief Engineer Brownlie, Foote asked, "Is she making water?" Brownlie answered that from what the second engineer had told him, she must be filling rapidly.

"Head 'er west by north!" Foote barked to the quartermaster, with the Douglas Island beaches in mind for the closest haven.

By then the rapidly filling bow was down and the stern was rising, with the result that she wouldn't respond to her helm. The screws were ineffective also, and the engines were stopped.

"Shouldn't we lower the boats, captain?" Foote was asked.

"Put them out but don't lower them yet," he responded, at the same time voicing his feelings that the forward bulkheads would hold.

But the wound was mortal. Whatever she had hit tore a huge gash in her port bow. In addition, a doorway that had been cut into the forward bulkhead to permit conveying coal back to the boilers apparently had been left conveniently open; water was pouring through it.

Quartermaster Ferry testified at the inquiry that from the time the ship struck until she became unmanageable was only about eight minutes. It was about 18 minutes later that the ship disappeared, he said. Some estimates put the time from crash to sinking at from 15 to 20 minutes. At any rate it was too fast for some to act in time.

Edgar Ashton, fireman on watch in the engine room, closed some watertight doors without any orders to do so. George Allen, third engineer in charge of the engine room at the time, gave no orders at the time of the collision because he didn't anticipate serious damage.

John Stuart, a fireman, heard "stifling cries from a stowaway beneath the forward deck after the accident." He and others knew the steamer was filling and got the man out and then went to the hurricane deck to help lower the boats.

Though Edgar Ashton was reported as saying there were only four stowaways in the fo'c'sle, George Ferry's story was a different one. He is reported as telling how 11 unfortunate stowaways met death in the coal bunkers that were adjoining the area of the collision damage. According to Ferry they had been passing coal, and unknown to the engineer, 11 were in the bunkers. When the engineer gave the order to close the bunkers to prevent the inrush of water, it imprisoned the unfortunate men.

Strangely enough, very little was made of the stowaways' part in the *Islander's* story when reports were made in the papers. Apparently also, they were not counted among those lost.

Neroutsos, in the meantime, had gone to the hurricane deck on the starboard side to supervise putting out lifeboats 1, 3, and 5. Captain Charles Harris, a passenger, and Second Officer George Powell took charge of boats 2, 4, and 6 on the port side. It was obvious by now that lowering the boats immediately was necessary.

Powell helped with number 4, the last to be lowered on the port side, "then went to the starboard side where number 3 boat was alongside with passengers, including ladies." He jumped into the water when the ship went down, but when he asked the occupants of a nearby raft to take him on they refused and said it was too crowded. He was in the water for 2 1/2 hours before being picked up. He saw no iceberg.

The rapid sinking of the *Islander* surprised many and, of course, was the major factor in the loss of those who would normally have a fair chance of being saved. Despite heroic efforts of some crew and passengers, there were reports of mistakes due to lack of discipline and confusion that cost lives. One was the report of a lifeboat leaving the ship with only seven men in it—all crew members—who refused to return to the ship on pleas of passengers still aboard. The lifeboats each had a capacity of 30 to 35 persons. Edward Young, a Vancouver, B.C., passenger, said he saw some boats pull away with only a few people in them. He was in the water for about three hours, then was taken out unconscious and resuscitated on the beach.

Others reported considerable confusion and lack of sufficient warning to the sleeping passengers. Dr. A.W. Phillips, a surviving passenger who lost his wife and child, heard no sounds of anyone knocking on the doors.

Chapter Four

Walter Preston, a passenger, was awakened at 2:05 a.m. by the shock of the collision. After hearing voices in the hall, he and his wife got up and dressed. A group of passengers was standing around in the smoking room, dazed, as they went through. He and his wife reached the deck just in time for the last lifeboat. As the boat (number 3 starboard) was lowered, one of the davits broke, catapulting Deputy Customs Inspector Walker of Skagway out of the boat and into the water, and he drifted away.

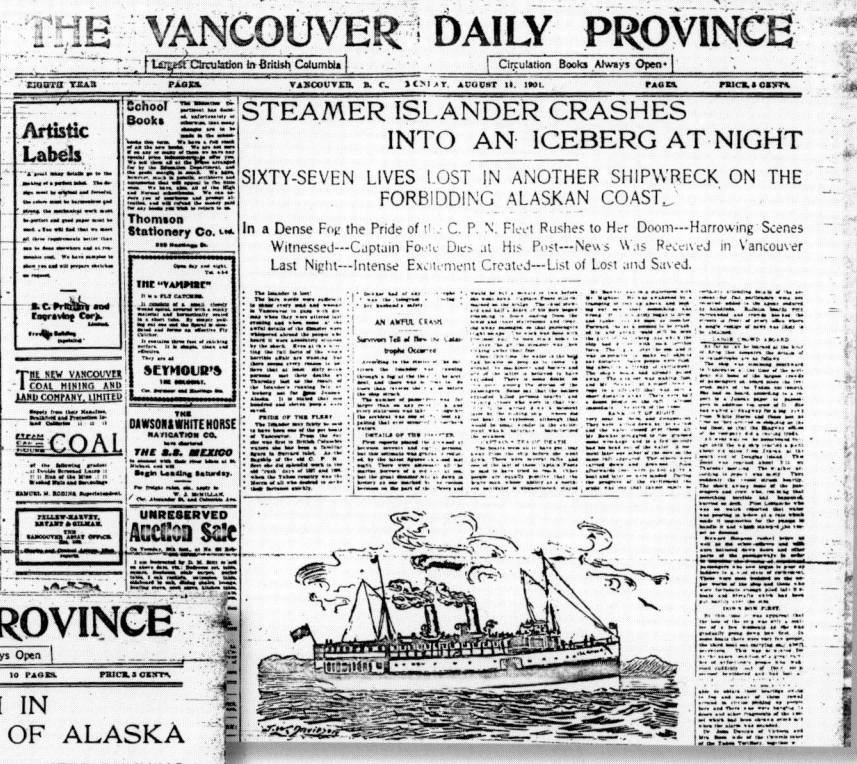

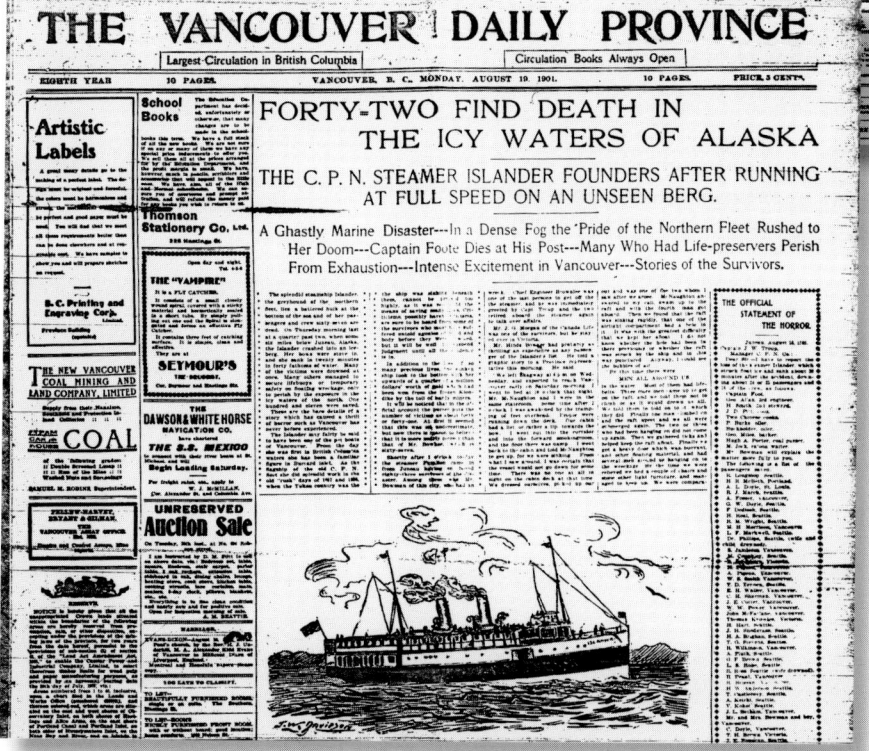

NEWSPAPER HEADLINES ABOUT THE SINKING.

The falls from the other davit were cut quickly and the boat landed in the water upright. Calls from a frantic Mrs. Walker brought answers from her floating husband and he was picked up.

As First Officer Neroutsos was superintending the starboard boats, a woman seized his arm and cried, "For God's sake, save me and my child!"

"All right," said Neroutsos, "I'll get you into this boat." As he was about to get her into it, some passengers jumped into it from the side of the deck. Their impact was what carried away the after-davit and threw Walker in the water.

"There goes the boat!" shouted Neroutsos.

"You can't save me now!" cried the frantic woman. "Oh what shall I do?"

"Yes I will!" responded Neroutsos, and grasping the child he rushed along the deck followed by the frantic woman. With a cry of "Catch this child!" he threw the child to those in the boat below and then assisted the woman to a place in a boat.

A hero of the disaster was Second Steward Horace Fowler. He stayed below to the last to arouse passengers. His neglect of his personal safety cost him his life.

Deckhand H.H. McDonald was sleeping in his quarters in the fo'c'sle when the ship struck. The blow struck opposite his room and burst in the partition between the fo'c'sle and the watchman's room. Water rushed in and McDonald went to the upper deck, telling everybody he met to keep calm. He then returned to his room, which by then was partly filled with water. He got some clothes, went topside to help lower the boats, and then had to jump in the water as the vessel started to sink. He had heard what he thought was crumbling of ice when the ship had struck.

One news story with the account of the sinking was headlined, "The Islander Sank in Fifteen Minutes." Others put the time more like 20 to 25 minutes from the time of collision. At the last she was canted forward at an angle of 45 degrees with people still clinging on deck; then she slid to her grave. She would be exhumed about a third of a century later.

Captain Foote stayed with the ship until it started to go down, when he jumped from the bridge into the water and got to a life raft holding 22 passengers. Foote was shaking with cold but hung on the raft for quite a while, according to witnesses.

The raft frequently capsized in the threshing struggle of the despairing survivors trying to last the night. Some frantic individuals commented that those with life belts should stay off the raft. One even pointed his pipe like a pistol and threatened to shoot Captain Foote and others if they didn't stay off the raft, according to witnesses.

Captain Foote was heard to say, "Well, you can tell 'em I tried to beach her."

Later, during the struggle for survival on the raft, Captain Foote despairingly cried out, "Well good-bye, boys!" and threw up his hands, slipped through his life belt, and sank out of sight.

Of the 22 originally on the raft, only 7 reached shore. Many were delirious.

Lester Gill had been awakened by people rushing on deck but did not think there was much of a hurry. He was on the top deck when the steamer went down. He was struck by flying debris and his scalp laid open, but was picked up and survived.

And the first-hand account of Joseph MacFarlane's experience:

I remember almost too vividly the elemental nature of man such a crisis brings out. There came the true colors. Some pushed and trampled on women and children to get to the boats and save their own lives; others forgot their immediate selves—and some, I fear, with fatal results.

My half-sleep reverie was rudely disturbed. We hit something solid. I didn't suppose it was serious at first. Within three or four minutes I heard women screaming and concluded to get up to investigate. By this time I could hear the engines racing and knew the screws were out of water. She was going down by the head.

I jerked on my clothes and tried to open the cabin door. It was jammed; I couldn't move it an inch. I yelled at the two other men who had occupied my cabin with me. They were still sleeping! I finally gave

Sunken Klondike Gold

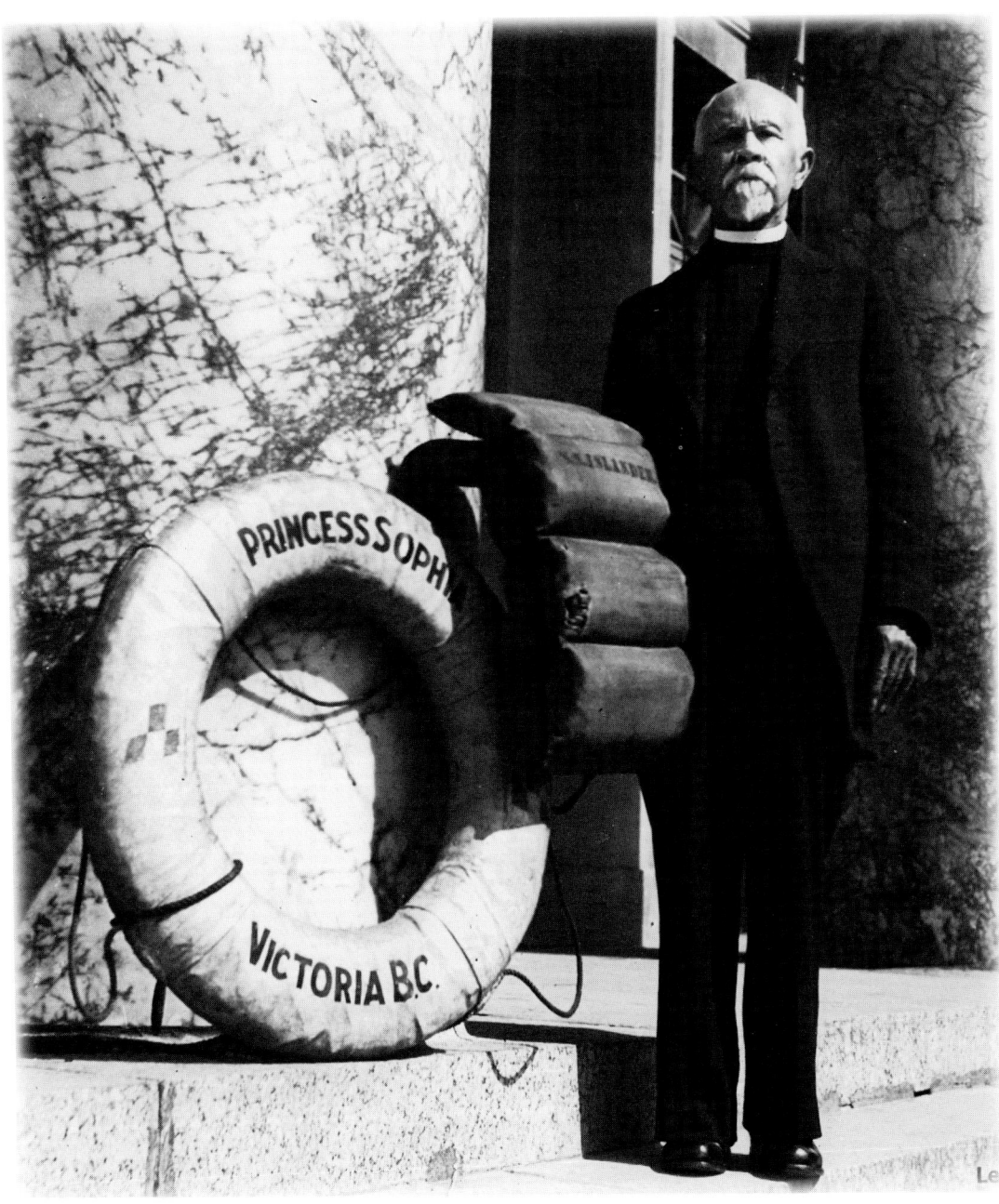

Father Kashavaroff, curator of the museum in Juneau's capitol building in 1935, with a life belt from the **Islander** and life ring from the **Princess Sophia**. Kashavaroff was also a priest in the Russian Orthodox Church and well grounded in certain phases of Alaska's history.

up on the door and went to shaking and cuffing them, so that they would realize our predicament. I knew it was a serious state of affairs by this time, as there was continual shouting and screaming and running along the corridor and out in the main large saloon.

At last the other two dressed hurriedly enough when I got them awake at last. We broke down the door with our heavy boot heels and threw ourselves into the milling crowd. Still we knew nothing of the exact trouble. I hailed the chief steward as he passed by on a run and asked him what had happened. He knew me and drew me a little to one side out of the jam, where he panted that we had struck a sunken iceberg but that he didn't think there was any danger for several hours, perhaps not at all as surely the bulkheads would float her. He begged me to help him with the women and children, to put life belts on them, to get them up on the main deck, but most of all to tell them that there was no real, immediate danger. I went about this, as I felt, myself, that there wasn't much danger of her sinking, since we were in Stephens Passage, close to Juneau, and probably only a mile from shore.

I found Dr. Duncan as soon as I could. He was assisting Mrs. Ross with her baby and niece, putting their life belts on them. I demanded that they get up to the main deck to try for a boat; just then the lights went out and I felt the deck tipping dangerously. She was still going down by the head. I believe now that it was a mistake not to have made the run for shore full steam astern, rather than to push the opened hull head-on against the sea.

We got on deck on the port side, and as the vessel was on a sharp slant by this time, I told them to hold on to the stanchions while I tried to locate a boat. I heard some voices up on the hurricane deck, so I climbed up there. There was a mate and some of the engine crew unfastening a life raft. I asked the mate what our chances were for getting in a boat; he replied that all of the boats had been launched, and that this last raft was for the crew.

"But my God, man," I said, "there are women and children on the main deck who've never even had a chance to be in those boats!"

All he said was, "I'm sorry, Mister," and threw the raft overboard, where they all jumped after it.

I fell down the ladder to my friends, who by that time had been joined by two or three other women. They listened tensely to my report. Dr. Duncan was holding the baby, Mrs. Ross was holding her niece by the hand, and all were clutching at the taffrail and the stanchions, for the ship was going down fast and careening badly. Mrs. Ross had a bottle of milk stuck in her belt for her baby.

I told Dr. Duncan that our only chance left was to jump, to jump right away and get clear of the ship as I was sure the suction of its final plunge would pull us down with it if we stayed much longer. I said I'd go first; if I found clear water I would call and for him to follow exactly where I had jumped or they might strike debris we could hear thumping against the ship's sides. I jumped out into the fog and called that apparently they could come about where I had with comparative safety. Instead, they hesitated at the rail.

Half-hidden by the mist and the dark, the Islander sank with a roar.

When the ship darted under, the rush of air back into the saloon exploded the ceiling, and the timbers fell about me like rain while I swam desperately against the whirlpool's suction. One struck me end-on between the shoulders, knocking me unconscious with its impact on my spinal cord. The icy water revived me just in time to strike out again from the waters still swirling over the ship. I began hunting a larger timber or a piece of wreckage to cling to, as swimming in my clothes with a bad gash bleeding in my back was rapidly wearing me out.

I could hear voices all around me shouting for help. Some were women's voices; and once I thought I heard a child cry out. The loudest of all of these was a Swede's shouting hysterically [with] every breath, "For God's sake; somebody come and save me, for God's sake; somebody come and save me." He kept this up 10 minutes, I believe, his crazed cry slashing the darkness with agony. It was becoming more nerve-racking than the urgent waters we were all fighting against, when I heard someone say, "You fool, if you can't swim, float!" Everybody laughed, in spite of imminent death; the climax of tension snapped under the wry humor of such advice.

Chapter Four

I continued swimming, slowly, painfully to where I could hear voices deceptively raising and lowering, even as gaps in the fog would bring glimpses of boats, rafts, swimmers, and, even so soon, shapeless, lifeless bodies floating gruesomely in their belts. I steered toward those voices, expecting to find a boat. For some time I seemed to be having no appreciable success, as the mumble of voices kept indistinct and their exact position from me was still uncertain in the fog. At last I heard a voice say, "Is that you, Captain Foote?" and I heard the captain answer, "Yes." The other called regularly to guide the captain through the dark, after saying, "Swim here if you can; we will make room for you." I concluded it was a raft, and if there was room for one, probably there would be room for two. At least, I might get a handhold, and have company. I let go of a piece of wood I had been easing my swimming with and made a beeline for those voices. I got there shortly after the captain, but found that 20 or 30 others, too, were hanging on the edges of the raft and swimming alongside. It was some time before I could squeeze myself between two desperate swimmers, but once there, and with my hand over the rope I made up my mind to hang on as long as there was breath in me.

I had been hanging on this way for 5 or 10 minutes when the captain, still apparently in bubbling spirits, asked the boys on the raft to sing, and he started a tune for them. During a lull and a little later I heard him say, "Good-bye boys; I can't hold on any longer;" and he let go, to disappear without more words. He was the first.

We thinned our ranks considerable as the hours went by. From then until daylight it was a case of fight to keep hold of the raft, as when a man would feel himself dying he would try to get up onto it, and when a number of them did this at the same time the raft would roll over like a log, and it was a case of let go or go over with it and down. I always let go, and fought my way back to it after the roll. Now and then numbed, icy fingers would cling no longer. That always made more room for the rest of us.

This kept up for about four hours, until daylight, but by this time we had dwindled down to 8 or 10 and the rolling over of the raft was less frequent. I was getting pretty weak and had lost all feeling in my limbs and body. The last I remember was that when the raft rolled over once more I went with it. As

it tipped I drove my elbow down between its boards. Lucky that I did, for when I came up, sputtering, someone in their struggles kicked me in the head and I went out for good. The elbow held.

My next recollection is of my waking up on the beach, in front of a bonfire. Half a dozen dead men were lying in a row alongside of me, but when the rescuers saw that I had life in me, they immediately got me to my feet, walked me and belabored my sore back until finally circulation resumed in my numb flesh. A drink or two of some fiery whisky, and I was myself again.

I looked over the bodies stretched out on the beach, most of them stokers from the engine-room. I noticed one of them had on the overcoat that I had left hanging in my stateroom on the ship, so curiously, I asked one of those firemen how the fellow came to have my coat on.

"Why, that's simple," he said. "When we knew we were sinking, down there in the hold, we swarmed to the decks in our dungarees and helped ourselves to warm clothes from the cabins we ran by. This fellow just happened to grab your coat." We buried him in it.

After we had been on the beach a short time, a steamer came out from Ketchikan and took us all up. Ketchikan's citizenry did everything in their power to make us comfortable, and I will always have the warmest spot in my heart for those good people.

The news of the Islander wreck was flashed around the world; its particulars are in old files of nearly every newspaper of North America. You can find in these old clippings the facts of Dr. Duncan's, Mrs. Ross' and the niece's bodies being recovered from the sea. The baby's, I understand, was never found, likely because no one had thought to protect it with a life belt. I have heard much about this wreck from other survivors. The matter of those watertight bulkheads failing was explained to me once by a member of the crew. He said that since there had been found an unusual number of stowaways in them, it had been decided to leave their doors open to give them enough air. I have heard that the crew who picked up our raft when I was unconscious and when my elbow was holding me to it was the crew that left me standing amazed on the hurricane deck.

After the plunge of the *Islander* and the explosion of debris over the fog-shrouded area, some survived in the icy waters and were eventually picked up. Some boats made it to shore and came back to pick up whoever they could find. Some boats milled around for hours blindly in the fog. One boat continued on to Juneau and got two small vessels to head back to the disaster area.

Several fires were started on the tree-covered fringe of Douglas Island by survivors who huddled there until picked up in the morning.

News of the disaster in Juneau was wired to Vancouver, Victoria, and Seattle with a resulting furor. The Vancouver *Province* headlined the story:

STEAMER ISLANDER CRASHED INTO AN ICEBERG AT NIGHT. Pride of CPN Fleet Rushes to Her Doom, Harrowing Scenes Witnessed, and A Ghostly Marine Disaster, CPN Steamer Founders After Running at Full Speed on an Unseen Berg. Many Who Had Life Preservers Perish From Exhaustion.

Then the account read, "The splendid steamship, *Islander*, the greyhound of the northern fleet, lies a battered hulk at the bottom of the sea and of her passengers and crew, sixty-seven are dead."

A special train brought Governor Ross with his surviving six children to Skagway where the CPN steamer *Hating*, held over for 14 hours, brought him to Juneau.

According to CPN reports of the time, the *Islander* was fully covered by insurance.

A funeral was held for some of the victims, including Mrs. Ross, brought to Vancouver or Victoria for funerals. The CPN Steamers *Queen, Hating,* and *Farallon* brought survivors and victims south to waiting relatives.

. . .

Sunken Klondike Gold

Flowers at the Juneau service for some *Islander* victims. Image G-01925 Winter & Pond photo, courtesy Royal BC Museum, BC Archives

Chapter Five

To Raise the *Islander*

Funeral wreaths for victims of the disaster were barely faded when on August 23, 1901, newspapers reported the question being asked of salvaging the Islander and recovering the gold aboard. In a small box-enclosed story, the Vancouver Province reported:

> To Raise the *Islander* —Mr. George McL. Brown, executive agent of the CPR says that it is impossible to tell until after the next trip of the Steamer *Hating,* whether the *Islander* can be raised or the treasure recovered. A representative of the company, probably Captain Troup, with Captain Johnson, Lloyd's agent at Vancouver will go up on the *Hating* and make a report.

The August 24 *Province* reported, "*Islander* Gold May be Raised—Quarter of a Million is the Plum. Diver John Moore of Vancouver is prepared to try to break the world's deep sea diving record." Moore felt it would be feasible if the *Islander* were no more than 35 to 40 fathoms down.

The attempt, said Moore, would be made possible with a new-type diving dress, or suit, available in London. It consisted of a copper helmet, the upper half copper plate and lower half consisting of a series of metallic springs covered with a very strong waterproof material. Arrangements could be made to adjust the height to fit the diver, and it was equipped with pressure valves to handle great depths.

However, as CPR people found out, the *Islander* was at a depth considerably more than six fathoms (240 feet), making reaching her with the available equipment impractical and raising her out of the question.

The subject of reaching and salvaging the treasure was raised several times after the tragic sinking. The CPR was compensated by Lloyd's of London for the insured value of the ship, though obviously it did not cover her traffic and prestige loss. But the CPR quickly and wisely gave up the idea of trying to raise her from her actual depth of 350 feet, and Lloyd's did likewise.

During the following years the stories of the gold aboard grew with repetition and the idea of raising the *Islander* was brought up several times. Several sources in Victoria denied that there was treasure aboard the sunken ship but were countered in part by other reports.

In a newspaper item in the summer of 1901, H.H. Morris of the Canadian Bank of Commerce, said, "The output for the Klondike this year will be considerably more than $20 million." The transport of this gold undoubtedly came through normal means and wasn't advertised. These reports bear out the fact that at the time the *Islander* sank, gold was being shipped or carried southbound in larger amounts than earlier in the summer.

Figures taken from records of the Gold Commission showed shipments of gold from Dawson City to Skagway as follows (in millions):

May 1901: $1,000	July 1901: $9,725
June 1901: $5,918	Total: $16,643

Apparently the August total was not compiled at the time, but it was assumed to be a large increase over July because of late summer cleanups.

The *Islander* had a strong room on the main deck aft port side, which held substantial pokes and express shipments. The Alaska Pacific Express had a shipment of gold aboard the *Islander*—how much was not known to the public.

The first effort to locate the wreck of the *Islander* was made by Henry Finch, a Seattle diver and salvage man, the year following her sinking. Taking his tug, *Henry Finch,* to Juneau, he established a temporary camp on the south shore of Douglas Island, not far from Point Hilda. Despite many mechanical problems and other

difficulties, he dragged the area of Stephens Passage involved in the *Islander* sinking and presumably located the sunken vessel.

Finch's original log, which recorded the search in meticulous detail, is in my possession. Excerpts are fascinating; Finch or his recording officer wrote about every movement of the tug or action of the crew. As I read it, I got the impression of a series of still photos becoming a motion picture. As part of the actual salvaging in 1933 and 1934, I have empathy with Finch and his crew. If only he could have been on hand for that operation.

Excerpts of Finch's log follow.

> *Ship's log June 10, 1902, Tug* Henry Finch. *5:15 P.M. Left Stetson & Post's dock, Seattle. 6:15 P.M. abreast West Pt Light, Course shaped for Apple Cove Pt. After dropping anchor off Port Townsend, Washington, they "lay at anchor making alterations and improvements to engine." This was the first of a series of bouts with a balky steam engine, trouble that continued throughout the trip north and back.*

> *On June 24 another discouragement is recorded. After leaving Bella Bella, B.C., at 6:00 a.m., "7:40 P.M. a commotion heard astern and Captain Finch was summoned. His son, Loren Finch, was found in the water closet lying on the floor. All hands worked on him until 9:15 P.M. when we cast anchor. The general opinion . . . is that he had an attack of heart failure and died immediately." The statement was signed by seven, including A.M.L. Hawks for the charterer; Henry Finch, captain; and Fred Getliffe, chief engineer.*

Numerous mentions of working on the engine and many rainy days follow. June 29, 8:15 A.M. records a reconnoitering trip to the scene of the *Islander* wreck.

> *July 1, spent most of the day ashore fixing camp. July 2, prepared to leave for* Islander *camp [apparently near Indian Cove, Douglas Island]. 3:52 . . . Stood NW along Douglas Island shore to point beyond Pt. Hilda.*

Then after several passes, Finch dropped the grappling iron and dragged along Douglas Island Shore to Indian Point. The following days included cruising around in small boats, working on the balky engine, and repeated passes and drags. With engine trouble on the tug, Finch on July 12 recorded,

Spent the day dragging with small boats from Hilda Cove toward Hilda Bay. Covered inshore for about 2 1/2 miles in 5 to 10 fathoms but found nothing of importance. Engineers busy working on engines all day.

July 15, 8:42 P.M. Landed at Treadwell Warf [sp] to get RR iron for drag weights and see about casting for engine. [In 1902 Treadwell was the site south of Juneau on the Gastineau Channel where a rich gold mine was to flourish and during World War I collapse with the weight of the channel water above it.]

On July 16 Finch contracted with owners of the tug *Yukon* to drag with the *Finch*. But on the next day when the *Yukon* was supposed to leave, her captain sent word she had blown a stay bolt and would be delayed.

By now Finch had obtained a new second engineer, Charles Rice. The first one had quit or had been fired—a point that wasn't made plain, but the problem with the engine had been plain enough.

As if Finch didn't have enough problems with his tug, the tug *Yukon* proved a problem also, the main one being her inability to keep up with the *Finch* when the two proceeded up or down channel on a drag. Finally the *Yukon* stopped and the *Finch* had to get her in tow. Then the *Yukon* fouled the drag line in her wheel and had to be beached to clear it.

Of interest to mariners and fishermen of the area are the entries in the log recording the directions the tug traveled. Typical were those of July 20, when she made a direct run of approximately 6000 feet from her base toward Oliver Inlet on Admiralty Island, then about 800 feet east of Indian Point, and on and on.

Then the *Yukon* had to get a new engineer, and the *Finch* picked up more railroad car wheels and iron for drag weights from Treadwell.

Finally contact was made. On August 4, 1902, a windy and rainy day, is the following from the log:

> *1:15 P.M. Swing out and dragged on Islander's course W of Indian Pt. to Hilda Bay.*
> *2:45 P.M. Swung about and headed E back to Fisherman's Hut Pt.*
> *3:35 P.M. swung about to port and headed W. Inside ship's course.*
> *4:15 P.M. swung about to starboard and headed E. Inside ship's course.*
> *4:40 P.M. fouled on ship when off waterfalls on Douglas Island which stopped* Finch's *engines.*

This is thought to be the spot where the *Islander* lay, and the drag line had fouled on the wreck. A buoy was placed over this spot.

The following day, August 5, the weather was nasty with strong winds and rain, but further dragging was carried out to double-check the spot. Additional checking was done during the following several days; presumably, Captain Finch was convinced this was the *Islander*, but the depth of the wreck was beyond his ability to reach in his diving suit.

In later years when the enthusiasm of would-be salvagers waxed profuse, they got a frigid reception from the CPR marine division. Undoubtedly the operation of the famous Princess ships didn't lend itself to what might be considered poor public relations reviving *Islander* disaster stories in particular and Alaska shipwreck stories in general. Tales of treasure were pooh-poohed. But conflicting with the official stance were the background stories.

Among those contending the *Islander* carried a sizeable shipment of gold were six witnesses from whom signed affidavits were obtained: William S. Herbert, a surviving *Islander* passenger; A.E. McCormick, *Islander* seaman; John S. Glenn, wharfinger for the White Pass & Yukon Railroad; J.C. Dumbolton, Bonanza Creek miner; M.E. Bennett, White Pass & Yukon cashier; and Bert Sparrows, former Skagway longshoreman.

Herbert was engineer for the Canadian Klondike Mining Co. and the Yukon Gold Co., which brought him in direct contact with the cleanup and smelting room for gold bullion for the shipment. He estimated the strong room contained between $2 and $3 million in gold bullion boxes. He had been assigned stateroom number 2 on the starboard side forward. "The adjacent room immediately forward of mine was temporarily fitted as a strong room," he declared. Herbert had 16 years' experience as a miner and in handling gold.

McCormick, quartermaster on the *Islander,* declared, "Of the gold carried at the time of the sinking, it is my honest belief there was more than $2 million in gold aboard."

Glenn, who was an employee at the dock of the White Pass & Yukon Railway, declared that the gold was shipped in two different-size boxes, in pokes, and in leather mail sacks. "The largest boxes each carried from $50 to $60 thousand in gold each and the smaller ones $25 to $30 thousand in gold," he said. The boxes were of spruce, wrapped with sheet iron, and lined.

"Most of the gold was being handled by Wells Fargo Express Co. at the time," declared Glenn. "From what I remember, one of the largest cleanups was being shipped on said vessel [*Islander*]."

Dumbolton told of coming out over the Dalton Trail to Skagway with his partners, Bailey and Griffen. They used two pack horses and carried out 320 pounds of gold, which ran about $17 to the ounce. All the gold was placed on the *Islander* except approximately 50 pounds, which was in Dumbolton's baggage. Dumbolton was delayed (fortunately for him) and failed to join ill-fated Bailey and Griffen.

Dumbolton doesn't know whether Bailey and Griffen kept their gold with them or transferred it to the purser's office. He declared it was the general belief there was at least $3 million in gold aboard the *Islander.*

Bennett was employed as cashier by the White Pass & Yukon Railroad at Dawson and was familiar with shipments. He said, "As near as I can remember, there were 15 or 16 boxes shipped daily during the summer months by boat to White Horse, thence by rail to Skagway." He said he had no knowledge of gold shipped in pouches; practically all the boxes were built of spruce boards one inch or more in thickness with heavy strap iron around them. Each box was marked with its weight and value, on average $30,000 per box.

Sparrows declared, "There were about 18 pouches or sacks of gold placed in the express room, next to the room used for the mail. The sacks weighed approximately 50 to 75 pounds each. I saw a great number of boxes—at least 25 of the kinds used for gold bricks or dust—all of the boxes being sealed or stored in the same room with the pouches."

He further recounted that just prior to the *Islander's* departure from Skagway, he was in the purser's office where he received his pay. He observed when the safe was opened that it had a number of pouches, envelopes, and packages. The purser's quarters was filled with all kinds of baggage, including some five or six boxes like those in the express room.

The purser's quarters was in the after part of the ship on the port side, just forward of the dining room. The mail room and express room were just forward of the purser's quarters, all on the main deck.

"One of the guards," declared Sparrows, "stated to another officer in my presence that there was more than $2 million in gold in that one place."

What red-blooded would-be salvager wouldn't be enthusiastic when reading the words of these witnesses! And if the report of the treasure in the strong room had been exaggerated, how could the contention of so many witnesses be other than encouraging?

Some, like Captain Charles Harris, contended that many pokes were kept under their owners' pillows and in their staterooms. If so, many were taken by their owners in their escape from the ship and lost in the struggles in the icy waters.

If George Washington Carmack, one of the discoverers of the Klondike gold, had been granted the power of seeing into the future more than 37 years, he probably would have considered the vision of the *Islander's* salvaging one of the strangest of all events of that period.

. . .

Chapter Six

Getting the Act Together

When I first met Frank Curtis in Portland in 1932, he was all fired up over plans for the *Islander's* salvaging. He and his crew had recently completed moving a 2000-ton gold dredge near Nome, Alaska, 1 1/2 miles in midwinter. It had attracted some attention in the North Country and added to his accomplishments of moving storm-stranded ships and the more commonplace moving buildings.

Curtis, born in 1885 in Kansas, came west and began working in the house-moving business in Oregon at the age of 18. Two years later he started a moving business of his own in Portland and soon after expanded to Seattle, where extensive moving was needed with the realignment of several hillsides.

In 1916 a coastal storm tossed a large barge of the Washington Tug and Barge Company high and dry on a rocky shore. Curtis and his crew moved the barge back to salt water near Grays Harbor, Washington, and later performed a similar task on 12 vessels tossed ashore in Florida after a hurricane.

Recalling his introduction to the *Islander* job, Curtis commented, "When I got back from the Nome dredge-moving job, I had several pieces of interesting mail waiting for me. One was from a good customer on moving some buildings. The other was from a fellow named Clithero. It said, 'There's a salvage job some of us would like to see you about.'"

Two days later he was talking to George Clithero, Carl Wiley, and a lawyer, Lewie Williams. Wiley told him of the depth problems, the tidal flows that stirred up glacial silt and obscured visibility, and his experiences diving in his bells in these waters. His bells were the key, for, as he said, "Regulation suits of those days would have been squeezed flatter than a pancake with the 150 to 160 psi pressure."

The Wiley Brothers Marine Salvors was the imposing title of his outfit, which had tried to recover the *Islander* treasure. The recovery was not profitable, however, for the brothers had raised mostly artifacts with a clamshell bucket. With their small barge, some small gas boats, a clamshell bucket, and inadequate hoisting equipment, they were under-equipped and ran out of money. Wiley's efforts had definitely established the spot where the Islander hulk lay, so the location was marked with a buoy and a watch kept on their investment.

Prior to Curtis entering the *Islander* story, a bizarre interlude had occurred. Unknown to Carl, a younger Wiley brother had conspired with a postal clerk to rob a branch post office in Seattle to get money to finance the renewal of salvage operations. They were caught and sent to prison. The publicity brought the Wiley operations to an end, though Carl was not implicated in the robbery plans.

Curtis was intrigued with the *Islander* challenge. The colorful background of the Canadian flagship of the Klondike days, and its equally colorful men who had sailed her, left a mark on North Pacific marine history as well as several unanswered questions about her cargo and sinking.

"The story of the *Islander* is an interesting one," said the lady in the Vancouver, B.C., archives to Curtis. "But you will have to go to the Provincial Archives in Victoria and the office of the steamship company for more details."

Curtis did, but at the steamship office he was rebuffed. From other sources, however, he was encouraged to act.

The challenge of the *Islander* and her reputed shipment became the dominant objective in Curtis's routine. His investigation into the *Islander* story was not to the extent of scholarly research, but it did prompt him to make a decision. Contacting numerous contractor friends in Oregon and Washington, he got them to provide financing and assistance to Curtis-Wiley Marine Salvors, Inc. for salvaging the *Islander*. His idea was simple but different from the usual: He proposed to outfit a lift ship, get supporting cables under the *Islander*, and raise her with the power of the tides on the lift ship. The diving bells were essential to the operations.

CHAPTER SIX

The Curtis-Wiley Marine Salvors was incorporated in 1932, with Frank Curtis of Curtis Bros. as president. Peter Gjarde, whose business was heavy construction and contracting, was the treasurer, and A.E. Hansen of Young Iron Works was secretary. Trustees, in addition to the above, included Robert Gillispie of the Mill and Mine Supply Co. and Frank Jackson of the Post Office Public Market. They were practical men, had faith in Curtis, and, no doubt, had a few drops of gamblers' blood.

As we looked at the diagram showing how the lift ship would ride on the surface above the *Islander* with 20 cables nicely surrounding her, the plan looked so nice and neat. Just like one of those stories in *Popular Mechanics*, I thought. And it looked very logical and simple, but is it going to materialize or is it just another fascinating story?

Depression pennies were scarce, but I, like the rest of the scheduled crew, was on the edge of my chair waiting for news of the plans for departure, so I invested in a long distance call to Seattle. Curtis wasn't in, so I got Lewie Williams on the line.

"Everything's going fine and dandy," he reported.

CARL WILEY AND ORIGINAL DIVING BELL HE INVENTED. THE BELLS CURTIS USED WERE SLIGHTLY SMALLER. COURTESY WILEY PHOTO

41

Employed in Salvaging the "Islander"

tles which the operator picked out of the ship's pantry in the 1930 expedition. The bell has withstood pressure at a depth of 900 feet.

The "Islander" has been the subject for conversation among contractors and salvage men of the Pacific Coast for many years. Seventy-two lives of the 145 persons aboard were lost when the ill-fated ship struck an iceberg and went down in five minutes more than twenty-nine years ago. The gold was being shipped at the time of the gold-rush excitement in Alaska and the Klondike territory.

"The Griffson" lifting the wreck of "The Islander" with twenty 1½-inch lines.

Page Nine

"The Young Iron Works has started building the 40 winches, and they plan to put the *Griffson* in dry dock to get her ready." That was good news. The winches were designed to ratchet or wind up the 1 1/2-inch lift cable between tide lifts, and each was supposed to have a load capacity of 21,000 pounds. The *Griffson* had extra ratchets like a Beebe hoist and were to be manually ratcheted and wound, with a crew member working the long handle of each to tighten the cables between lifts.

The *Griffson*, a Ferris-type wooden freighter, was built near the end of World War I and never had a power plant or propeller in her. James Griffiths and Sons used her as a seagoing barge hauling gypsum from Mexico, but she had been sidelined in Lake Union, Seattle, by the Great Depression of the 1930s like a lot of other hulls. With her approximate capacity of 4500 tons, she seemed suitable for the lift job.

About a month later, an inconspicuous story appeared on the financial page of a Portland paper. It reported that a savings and loan institution in Spokane was threatened with closure. Within a week several others in other parts of the Pacific Northwest were reported in similar circumstances. It wasn't too much later that President Roosevelt declared a bank holiday, but the savings and loans were the first, for in those days there was no FSLIC, Federal Savings and Loan Insurance Corporation. It was not long after this news that the impact was felt on the salvage project.

DIAGRAM OF THE **GRIFFSON** LIFTING THE WRECK OF THE **ISLANDER** WITH 20 LIFT CABLES.

CHAPTER SIX

THE BARGE **GRIFFSON** AT LAKE UNION, SEATTLE, FRAMED BY THE BOW OF THE **FOREST PRIDE**.

"Looks like we'll have a little delay on our starting date." It was Russell Clithero on the line. He reported that the savings and loan closure had affected most of our contractor-backers for the project, and they had to reduce or withdraw much of their commitment.

Like a movie scene, the summer and fall of 1932 dissolved into winter, with the *Islander* project on the shelf. To prepare myself for making a photo record of the salvaging, I went to work for a commercial photo studio in Portland during the waiting period. The owner, Claude Palmer, became enthused about the salvage project and was supportive with photo supplies and equipment.

I recall an amusing incident during that time that is representative of the many changes in photo equipment since that period, in this case flash equipment versus the modern strobe.

Franklin D. Roosevelt on his presidential campaign tour of the west had just arrived in Portland by train. Prior to his speech at the City Auditorium that evening, his limousine had just pulled up in front of the old Portland Hotel, where Palmer and I would take his

THE *GRIFFSON* ANCHORED.

CHAPTER SIX

photo. The 8x10 camera had been set up and, subject to last-minute adjustment, aimed at the anticipated stop. The flash gun with its load of magnesium powder was readied for sufficient exposure in the evening light.

FDR smiled his famous smile

Ready! Click went the shutter and click went the flash gun, but no flash!

Quickly Palmer reset the flash gun and shutter and I grabbed another film holder. That wonderful smile came on again, but the damned cap and powder didn't ignite!

Tempus was fugiting, as they say, and FDR graciously suggested the photo be tried again at the train depot after his speech. We lamely backed off with our gear as the visiting party went into the hotel. Palmer later got an excellent photo at the depot.

Blending my early background in newspaper and trade journal work into the requirements of a photographer for the prospective *Islander* project, I was planning what I would need in the way of equipment. A small darkroom adjacent to my sleeping quarters aboard the *Griffson* was promised.

"For quality work take an 8x10 camera, and you can print contact prints right on the job," my mentor told me. The 8x10 was the ideal commercial camera of the time. Even five years later it was required by many manufacturers for their field photos.

(The 8x10 still has its place, but later on the windy, rain-swept deck of the salvage ship, on many occasions I preferred my 3 1/4 x 4 1/4 Graflex. In years following the salvage venture, and in the more than 40 years of my own commercial and aerial survey operations, the large 8x10 negative served its purpose in a controlled environment.)

Winter dissolved into spring. By now some observers had figured the *Islander* project was finished, but Curtis and his associates were determined. Curtis felt that more than his money was at stake, and a lot of his friends had their savings in the venture. In looking for help, they were directed to Norton Clapp, a Tacoma lawyer and at the time a junior officer and stockholder in the Weyerhaeuser Timber Company (later he would be president of that firm and in the early 1960s would invest in construction of Seattle's Space Needle).

SUNKEN KLONDIKE GOLD

Leonard Delano Photo

CURTIS (LEFT) AND WAHLBORG EXAMINE ONE ANCHOR WINCH ON THE **GRIFFSON**.

CHAPTER SIX

CAPTAIN JOHN WAHLBORG (RIGHT), WHO COMMANDED THE **GRIFFSON** ON ITS MANY TRIPS AS A FREIGHTER OUT OF SEATTLE, LOOKS OVER THE ROUTE MAP TO STEVEN'S PASSAGE WHERE THE **ISLANDER** LAY. WITH HIM IS FRANK CURTIS.

However, his entry into the salvage organization brought some drastic changes in several policies, one of which was public communications and news releases. These drastically affected me and, of course, Curtis's objectives.

After new financial life was given to the project, Curtis still had the responsibility. The winches, would they hold? The old *Griffson*, a wooden hull cast into the ship boneyard, would it do the job? And a bunch of house movers, loggers, and rigging mechanics, could they cut the mustard?

Curtis had once remarked, "It's just like a big moving job. It takes a while to get the timbers laid out and the jacks a'workin'."

Quite a moving job! Nothing like it in the environment and circumstances of the *Islander* had been done as a private venture that was on record. Later, many deep sea projects—some of major proportions during and after World War II—would be accomplished. The British and U.S. navies would work with an abundance of equipment and billions of dollars. The Islander project, however, pinched on financing, was setting out to raise a hulk sunk for almost a third of a century and deeper than diving suits could then attempt to go.

Said Curtis and his crew, "This is a real horse race! Get out of the way and let the mud fly!"

. . .

Chapter Seven

Underway

It was May 1933. The Great Depression of the 1930s had the economy hypnotized, but after many delays and frustrations, financial setbacks and organization problems, the day to start was near. A waiting period of almost a year had followed the collapse of the initial financial subscriptions and Clapp's entry into the financial picture. Not all the winches were completed, so the remainder would be finished at the Young Ironworks and shipped north later in the summer. Money lately injected into the project was at last flowing as progress was made, step by step.

With spring already turning into summer, would we get away in time? Preparations involved numerous details some landlubbers had never thought of and some ordinary sailors could not imagine.

In late May we gathered at Lake Union in Seattle. After the delay, enthusiasm was noticeable. Curtis was busier than a bird dog but cracking corny jokes as usual.

In each room in the stern section where quarters had been installed, radiators would provide heat. They were connected to the steam boiler at the opposite end of the ship and later were to perform diligently. However, in the first season, when the cold northeast wind cooled things down considerably, at times they couldn't do much more than keep from freezing, themselves.

Most of the crew members were from the Seattle area. Many were from the Curtis Bros. building moving crew, including Perm Waddell, Frank's son-in-law; and Shorty Curtis, Frank's nephew. Also along was Russell Clithero, who had worked on the Wiley salvage venture. Dick Kohler, ex-ship bosun, added supervisory experience.

THE **GRIFFSON** BEING READIED TO DEPART FROM SEATTLE.

Then there was Blair Hetrick, a burly and capable young logger from Port Townsend, Washington, who was to do key work in cable splicing, logging, and other important jobs. The Scandinavians, Sigard (Si) Hellene, Frank Sandberg, Ernie Peterson, Ernest Olsen, and Clifford Johnson, were on hand. Carpenters Ed Simons and Leo Blessener added maturity and experience. Will Warren, Dick Triple, Gerald Banta, Willard Robbins, myself, and others contrasted with the middle-aged Dick Kohler, Slim Hurlburt, and Dave Olmstead, the cook. The tug *Georgia's* crew included, in addition to its owner Captain J.C. Brownfield, George Rose, George Busby, and C.C. McAlister. Olmstead's helpers and galley crew included Al Clithero, Ray Clithero, and Olmstead's son, Larry. Cap Charley Hayes and some others were to join us on the job. I was signed on as a rigger. Work in outfitting and carpenter work in building the crew's quarters continued into June. Permits and paperwork were obtained and prepared.

And then the day came when we were underway!

The old, folded copy of my log at the start of the trip reads as follows:

12 June Monday, 1933 - Left Lake Union dry dock about 5:30 p.m. lashed to the 500 HP steam tug Georgia. *The* Starling, *a smaller tug, helped us on the way out. A fairly good-sized crowd at the dock composed of members of the crew's families, relatives, and friends and a few curious saw us off. Then through the channel under the George Washington and Fremont bridges, a few more relatives crowded at the head of the traffic waiting at the open draw of the Fremont Bridge to wave goodbye. Through the locks and to Richmond Beach, where we docked at 10:45 p.m. and took oil for the tug and the* Griffson's *tanks - 681 barrels of oil and 100 barrels of gas. We had taken on 480 barrels of oil at Seattle. The* Undine, *our little gas boat which we are going to use for odd jobs and running back and forth to Juneau, had gone on ahead with the scow in tow. We had finished taking on oil at Richmond Beach and she still hadn't shown up. The wind was blowing a heavy chop and so the Starling set out with some provisions to find her. They*

found her at 4:00 a.m., out of gas. Apparently the headwind was too much for her with the scow in tow to reach our stopping point with her supply of gas.

From the time we left Puget Sound until our arrival on June 20 at our destination in Stephens Passage, Alaska, the trip was routine to the old hands aboard the tug. But to the landlubbers, including me, it was a new experience. The *Griffson* was riding high with the wind and tide and not much ballast. Standing watch in the wheelhouse in the stern of the old freighter, one soon became aware of her reactions. One crew member likened her to an old cow—a friendly but stubborn old cow. She was slow to respond to the wheel, but once she started turning, look out!

It was obvious that limited correction was needed in most cases. On the other hand, when you learned the feel of her response, corrections in steering could be anticipated to counter the elements and changes in our course. Though we were in tow of the tug, we had damned well better play follow the leader in the tight spots. One of these was Seymour Narrows—before the rock was blasted out of the Narrows midchannel.

14 June, Wednesday - the second day since departure, our little procession passed Campbell River, bucking an incoming tide at 7:00 p.m. At midnight the tide was with us when Gary Banta and I relieved Perm and Si. Soon we approached the Narrows where the tidal flow was bottlenecked down to a raceway. The tow cable was shortened.

The bow watch was alert. We were careful not to overcorrect. The wind was strong, but the tide took hold. We lined up with a turn to starboard, and the current accelerated as we entered the slot. The trees on the adjoining shore seemed awfully close in that blackness, with only the stars for light.

The trip through the Narrows was an exhilarating ride in the dark. Routine, you say? Not for us on the *Griffson* that first time. With our tow speed of six to nine miles an hour, we couldn't have bucked the tidal current.

CHAPTER SEVEN

CREW OF ISLANDER EXPEDITION

(REAR ROW) WILLARD WARREN, ERNEST PETERSON, DICK TRIPLE, AL WALKER, CAPTAIN GEORGE ROSE, BLAIR HEDRICK
(THIRD ROW) CLIFFORD JOHNSON, RUSSELL CLITHERO, CAPTAIN CHARLES HAYES, GERALD BANTA, O.H. (SLIM) HURLBUT, LEO BLESSENER, GEORGE BUSBY, C.C. McALISTER, ERNEST OLSEN.
(SECOND ROW) DICK KOHLER, THURMAN (SHORTY) CURTIS, SI HELLENE, WILLARD ROBBINS, PERMAN WADDELL, FRANK SANDBERG, CAPTAIN FRANK CURTIS, CHARLES CASELY.
(FRONT ROW) EDWARD SIMMONS, DICK FRARY, ALBERT CLITHERO, RAY CLITHERO, LARRY OLMSTEAD, CAPTAIN J.C. BROWNFIELD, KELLY GARFIELD, DAVID OLMSTEAD.
Photographed by LEONARD DELANO.

CREW OF THE EXPEDITION, 1933.

Any communication with the tug was by light signaling. No CB radios in those days.

When the turns were sharp or the wind and water were rough, our thoughts went back to Russ Clithero and Cliff Johnson in the gas boat, *Undine.* It and the scow, *Bremerton*, were in tow behind the *Griffson*.

"Not getting much sleep I'll bet!" commented Gary about Russ and Cliff.

Gary and I took turns at the wheel for an hour at a time, both of us peering out at the old Griffson's bobbing bow all the time we were on our four-hour watch.

Quiet waters followed the Narrows, and after we passed the scenic surroundings of the Alert Bay cannery, the crew got busy making deck gear fast for entering Queen Charlotte Sound. That afternoon I stood the 12:00 to 4:00 watch alone on a quiet, routine course. But as we entered Queen Charlotte Sound at 7:00 p.m., the pitch and roll of the ocean began.

A bottle of vanilla broke and dropped to the floor with other items in the galley. Its fragrance was evident the following days in my darkroom directly underneath. At this point our landlubber legs and stomachs were introduced to the pitch of the open sea. The scow and the gas boat bringing up the rear had an even livelier time.

SOME LIFT CABLE ON BOARD THE **GRIFFSON** BEFORE STOWING.

Chapter Seven

The tug **Georgia**.

Names of Fitzhugh Sound, Lama Passage, the little Indian town of Bella Bella, and Millbank Sound show next on the log, familiar names to northbound mariners, then Kleatu Pass, Cone Island, Coghlan Harbor, and Lowe Inlet, the latter a narrow passage flanked by beautiful peaks. In this rugged country we occasionally saw a little house of rough boards tucked away at water's edge at the mouth of a canyon.

En route, crew members were working on several outfitting projects. One was completion of the steam generating system to operate the generator for our lighting system.

Stopping briefly at Ketchikan, an Alaska port of entry, we obtained clearance papers, took on water, and transferred fuel oil from the *Griffson's* tanks to the tug *Georgia*.

Northbound again, the procession marked time in Clarence Straits for an ebb tide and then went through another bottleneck, Wrangell Narrows.

20 June, Tuesday - All hands were called to an early breakfast and at 6:30

CAPTAIN J.C. BROWNFIELD OF THE **GEORGIA** BEFORE LEAVING SEATTLE.

CHAPTER SEVEN

a.m. passed several little icebergs immediately south of Taku Inlet. Crew members wore rain clothing and slickers because the murky weather contributed a chilly and steady rain. We all looked out to the Passage, which is to become our base for two seasons. There, in mid-Passage, a small fishing boat doing guard duty over the sunken ship awaited us. A bobbing outboard-powered riverboat was alongside.

Shouts. Two and then three figures appeared on the fishing boat's deck. The *Beloit*, its two crew members—the Knapplands—and Cap Charley Hayes waved us a welcome.

After a brief anchorage adjoining Admiralty Island nearby, the *Georgia* took the *Griffson* out to the *Islander's* estimated location, and the process of anchoring her began.

. . .

THE **GEORGIA**, **UNDINE**, AND ONE OF THE SCOWS TIE UP ALONGSIDE THE **GRIFFSON** AT TEMPORARY ANCHORAGE NEAR ADMIRALTY ISLAND.

57

CHARLEY HAYES GETS READY TO DIVE IN "THE THING."

Chapter Eight

Grappling in the Dark

John and Carstine Knapland, father and son operators of the fishing boat *Beloit*, were typical Alaskan fishermen of Norwegian descent. They were right at home in this southeastern Alaska coast area, so much like John's native fjords. John still had the home country slant to his English. Carstine, a big, capable fellow of 20 years, had little evidence of Norway when he spoke, which wasn't often.

"Lots of curious people about dis business," John commented. News of the upcoming salvaging had spread along the waterways, and the occupants of the *Beloit* were targets of frequent questions when they went to Juneau for supplies or from an occasional visitor alongside their anchorage in the Passage.

However, as one of the *Griffson* crew observed, "The people of the area would like to know what's up, even though they did know what's down."

It was clear the *Beloit* crew had been expecting us for some time and had almost given up on a definite arrival. Then, a few days previously, they had gone to Juneau and received a telegraphed message from Seattle that we were on our way.

The buoy marking the *Islander's* location in the mist-ringed Stephens Passage had been tended occasionally the previous winter and regularly in the spring and early summer. It had been a lonesome vigil. But now that the planning had gone this far, the salvors didn't want any claim jumpers to foul up the detail. The spot was more or less in line between Point Hilda on the southern edge of Douglas Island and Green Cove on Admiralty Island across the Passage to the south-southeast.

Here, 32 years earlier, the object of our salvage project had plunged to the bottom. The place looked peaceful enough now—lonely too. Its appearance belied the time in 1901 when its passengers and crew got the shock of their lives.

The *Beloit* stayed with us most of the summer, running errands and giving her limited help in teaming up with the *Georgia* when the *Griffson* had to be moved. The deep-throated chuga-chuga of the *Beloit's* diesel was a reassuring sound when the *Undine's* aging engine broke down.

Breakfast was early and welcomed the morning of June 20, for the crew members' hearty appetites were whetted with the anticipation of the work before them. Dave Olmstead, the *Griffson's* genial "chef," correctly estimated the demand with generous stacks of pancakes; piles of hash brown potatoes, bacon, and eggs; and gallons of black coffee. He and his helpers were busy.

Brownfield, Curtis, and several members of the crew discussed the preceding tide. The first job was to position the *Griffson* and put out anchors port and starboard, fore and aft. Several days were to be spent this way, for the checking of the *Griffson's* position was necessary for divers to estimate the location of the *Islander* below. Also, the ebb and flow of the tide in the Passage would swing the *Griffson* and prompt the *Georgia* to jockey her back and forth as needed. And later, as we were to find, the *Griffson* would have to be moved several times.

On the scow an A-frame was rigged for carrying out and releasing the anchors. The *Griffson* was held with a bridle attached to the scow so the crew could establish the *Griffson's* position when the anchor was dropped. Then, each anchor was released with a splash. An axe-wielding crewman expediently cut the hemp. The thought of the anchor fouling a line and taking a crewman overboard had entered the detail's minds, and the axe man stood clear of all lines at the critical moment.

When the *Undine* crew prepared to go to Juneau that evening, some had hopes they might get an evening ashore. Their hopes were quickly squelched. "She's going to have to lay over to get her damned clutch fixed!" commented Cliff Johnson with disgust as he recalled the recent use of the little utility boat. That was that.

CHAPTER EIGHT

PUTTING OVER THE BELL ON ONE OF THE EARLY DIVES.

Cliff and Russ Clithero were still recuperating from some of their bouncing aboard the *Undine* on the northbound trip. It hadn't been all bad, but they did admit that at times they envied us aboard the *Griffson* and the *Georgia.* They had, however, come aboard the *Griffson* for meals whenever feasible, which was most of the time.

The *Islander* lay in the approximate center of the main shipping channel. According to Hayes, the *Griffson's* bow was positioned over the center of the Islander.

While stringing out the line for the stern anchor on the port quarter, the crew almost ran into grief. The friction brake on the *Griffson's* team anchor winch on the poop deck gave way and the drum that was playing out cable began to spin crazily. Dick Kohler and three others finally checked the drum before the cable ran out.

Several crew members noticed small whales. They apparently were Orca or killer whales.

Buoys had been set out for certain anchor lines, and lights were put out on all rafts and scows. Signals marking the stationary salvaging operation had been hoisted on the *Griffson.*

TALKING TO THE DIVER IN THE BELL BELOW.

Preliminaries resolved, Captain Brownfield with four of his crew left to return to his Seattle operation, leaving Captain Rose and the engineer on the tug. Brownfield would be missed, that I knew.

In addition to the four (and later, five) anchors for the *Griffson*, each of the two cutting line scows was positioned with anchors quartering port and starboard of the *Griffson*. Gas donkeys were aboard to work the cutting line that would be under the *Islander*. When under the wreck, the line would be brought up and shackled to a lift cable, which would be "threaded" under the *Islander*. It was to prove a slow and discouraging operation.

Charley Hayes, a local gas boat man and one of the Wiley Brothers' contact men in the area, was a little shorter than most. His height helped when it came to fitting into the diving bell, which became known as "The Thing." Russ Clithero had previously been down when the Wileys tried to recover the *Islander* treasure, and he too was The Thing's occupant on several occasions. But Charley, because of his size, fit better. There were some who said it took a little goofiness in a man to go that deep in water under those circumstances, and Cap Hayes would probably have readily admitted it. Wiley's expedition had a larger bell available, but it was not operative when Curtis started.

Prior to sending down the cutting line and working it past the twin propellers under the *Islander*, numerous trips had to be made in the bell. As can be imagined, getting the line under the first time was something of a problem.

"Where's the damn *Islander*?" was the question first raised by the cutting line crews. They were jiggling the throttles of their engines back and forth to position the 700 feet or more of the swinging line in the dark below.

Then the diver in the bell, who could see only a few feet in front of him in the silt-saturated water below, would report the position of the cutting line as it related to the *Islander*. He would signal his tender to pull him up and get him out of the way. Then, to the cacophony of whistled signals and the whine of the donkey engines, the crews would play their line as if to catch a giant fish below.

Then would come the next question to the diving group. "Where in the hell is the cutting line?" they would ask while the cutting section was hung up on the propeller or some projection.

SUNKEN KLONDIKE GOLD

CREW MEMBER CLIFF JOHNSON BRINGS UP THE BELL BY WINDING BOTH THE LIFT CABLE AND TELEPHONE AND POWER LINE.

Down in the depths, where pressure could do strange things to equipment, where while squinting in the silt-clouded waters one had to limit his working area to a few feet, progress of the diver in the bell was bound to be slow. By the light of a little photoflood bulb, the drifting glacial silt looked like a heavy snowstorm.

The ungainly crab-claw arm could be operated manually from inside the bell in a limited fashion, and the bell was used mainly for inspection and reconnaissance. On telephone instruction from the occupant it could be shifted, but the 365 feet of cable that held it allowed for considerable leeway, which often necessitated more than one move to gain a desired position.

Beginning on June 25, Russ Clithero worked to activate both diving bells but had telephone and lighting problems. Lighting outside the bell was provided by a number 2 photoflood bulb put on the end of an insulated power cable and sealed with a rubber and tar paint. Water pressure was apparently no problem for the bulb. Weight of the bells was 1650 pounds each.

On June 26 Charlie Hayes made three dives in the number 1 bell and found the *Islander* to be lying about 100 feet to the starboard and slightly forward of the *Griffson* and an estimated 350 feet down. The jiggling and vibration of the long cable that held the bell was transmitted to the bell as the lift drum raised and lowered it. The diver's feelings inside the bell can be imagined, but as Russ said, "It was beyond description."

Charley, however, was not without words. "It's like going to hell and coming back each time, and that's a fact!"

As he also pointed out, if the long supporting wire had broken, the bell and its occupant might have stayed on the ocean floor. Chances of retrieval from the muddy bottom and darkness would have been like looking for a needle in a haystack in the dark, but fortunately the second bell aboard could have been pressed into service in an emergency. Because he had become familiar with the hulk below, it was natural that he continue diving because he knew his way around the murky depths.

Later the following year, diving was done in shallower water near the beach. Divers used a suit made by Charles Huckins, which made the problem and risks minimal when compared with the bell.

Charley, in casual conversations, was an exaggerator par excellence. In telling of the size of a brown bear he had hunted, the bear became almost too big for listeners to believe. Charley!" one listener burst out. "That size bear would need six legs, including two to hold his middle up!" So from then on Charley earned the title of "Bearfoot Hayes" or some similar appellation. However, as it was later conceded, the Admiralty Island Alaskan brown bear was *big*.

Because the water pressure was 150 pounds per square inch, it was necessary to thoroughly seal the helmet when it was put on the bell. First trips down allowed a small amount of moisture to get in, which was cause for concern until remedied. Oxygen was supplied by a small bottle that was renewed, or was supposed to be renewed, each time. Sometimes a quick look-see showed the oxygen supply was not at capacity. After discussing details with the diver before a dive, the operator or tender on shipboard, often Cliff Johnson, would closely monitor his situation.

By this time several crew members had received some minor lumps. I joined that category on June 26 when the released end of some new line being unwound from a reel hit my knee. The line had the end of a nail in it.

RAISING THE BELL, WITH PIPE FROM THE **ISLANDER** IN ITS MECHANICAL CLAW.

That day Russ Clithero relieved Hayes on some dives in the bell.

Diving continued every day; on June 28 Hayes made five dives. Not to be overlooked, Frank Curtis went down in the bell and fortunately landed atop the *Islander* hulk. Emerging from the bell on its return to the *Griffson* deck, his was the face of one who had seen the Holy Grail.

The last part of June was rainy and blustery, and on one of those days Cap Hayes had just come up from a dive when some visitors arrived. Just as the helmet was being unbolted from the diving bell, a Fisheries and Wildlife boat pulled alongside and a young occupant from it climbed up the *Griffson's* ladder.

"You Charley Hayes?" he asked the startled man in the bell.

Cap nodded his head with a reticent, "Yes."

"You are charged with illegal trapping and possession of martin skins," said the government man.

The look on Hayes's face was indeed that of surprise and consternation. He claimed that someone else had trapped the martins, but wouldn't say who. Obviously, he was referring to a trapping partner and not a salvage crew member, but his attitude of innocence apparently was only partly convincing.

He was given two months' suspended sentence. Not surprisingly, he elected not to dive anymore that day. We never heard more about the matter and assumed it was resolved. Circumstances such as these were received with mixed emotions by some Alaskans during the Great Depression of the 1930s.

The *Islander,* with its bow severely damaged, undoubtedly had penetrated nose first into the muddy bottom. During the course of almost a third of a century, additional glacial silt had settled on and around it. It was obvious there was no chance of working any lines under her bow, so the answer was to get them under her hull past the twin propellers at the up-tilted stern.

A four-sided serrated cutting tool had been built in Seattle to attach to the ends of the cutting lines to provide penetration under the hull. After more than a month had been invested in finding the sunken hull and positioning the cutting lines, and an additional week sawing back and forth with the cutting, Curtis went

into a huddle with some of the crew. Perm Waddell, Blair Hetrick, and Si Hellene were vociferous in their comments about the efforts and need for improvement.

An agonizing period of discouragement developed over the lack of progress. In that period of tenseness and growing doubt, the question arose of whether it would be possible to get lift cables under the hulk at all. Curtis himself was about ready to blow his cork. Word drifted back that he did bust loose a few times in town.

"The cutter doesn't get anywhere because it doesn't move the mud out of the way!" said Perm.

"What the hell! We've got plenty of anchor chain. Let's try a chunk of it!" burst out Curtis, whose background had taught him to improvise to fit the occasion. Blair Hetrick, although a bit reserved, was in favor of the change.

Using 50 links of heavy anchor chain, heavy enough to sink into the mud and move it out of the way, was the answer to the problem. In another day we made enough progress to consider the possibility of putting the first lift cable under the *Islander.*

On the job, being less defensive than the older heads and perhaps quicker to jump into situations, the newer workers of this type of operation were first to get a few bumps. In the hold of the *Griffson* were still reminders of its previous use. Amidships the cross beam timbers still had gypsum scattered over them, reminders of her cargo-carrying days from Mexico. After removing a cargo hatch one day in early July, several of us began the process of getting some deck equipment stowed below.

As usual that summer, it was raining. Not realizing or being warned of the possible consequences, I began walking across on the beams while carrying a sling. I never reached the other side. My feet slipped out from under me on the rain-slicked gypsum and down I went.

Like *Erewhon's* author would say, "I was lucky and the Lord was with me." I went between two crossbeams and landed below on a pile of old three-inch hemp rope, which saved my neck. I promptly got a free ride to St Ann's Hospital in Juneau where, after medical attention by Doc Dawes, they kept me a week with a broken

CHAPTER EIGHT

LIFT SHIP **GRIFFSON** DOWN AT STERN ON EARLY TEST LIFT.

SUNKEN KLONDIKE GOLD

right wrist, wrenched left ankle and right knee, and various cuts and bruises. Well, I thought, one learns from experience. My fall was the first of a rash of accidents involving crew members handling gear. One man fell down another hatch and was seriously hurt when he landed on reels of steel cables. He was sent back to Seattle. Cap Hayes, while working on the cranky gas boat *Undine's* engine one day, was badly scalded on his face and arms when a water cock blew off. Several minor accidents resulting in broken toes, cut hands, and so on occurred. Firing and resigning depleted the crew by two more. It was to be expected that this was no picnic, but during the first several months the frustrations caused a depressing air to settle over the *Griffson*.

• • •

BLAIR HEDRICK (LEFT) AND SI HELLENE WITH A SECTION OF THE ORIGINAL CUTTING LINE THAT WAS REPLACED BY A LONG SECTION OF LARGE ANCHOR CHAIN.

Chapter Nine

On a Toot

THE TWO MEN ATOP the floating platform in midchannel of Stephens Passage tensed as the swells from the passing steamship began to rock their perch and left them bouncing in its wake. As the wind whipped the mixture of spray and rain onto Perm and Si, they turned their backs to it, each with one hand grasping the collars of their slickers.

They no longer cringed from these swells or gusts of driven spray. Their attention was on the other scow more than 2000 feet distant across the channel and its signal halyard now changing from red to green. A whistle blast from the number 2 scow reached Perm's ears. He responded with a whistle blast and threw his steam donkey engine into gear.

The steam engine responded with a familiar screech and chatter, and the drums in front of him began to wind, filling with dripping cable as it emerged from the depths.

When the drum was almost filled with cable to a mark indicated on its side, Perm cut the steam throttle, threw it out of gear, jammed his foot on the brake, and yanked his signal cord for a loud blast from his steam beast alongside him. At the same time Si switched his signal flags from red to green and checked the fuel flow into the firebox. The number 2 engine in the background began to chatter and the drum in front of Perm began to unroll its burden of lift cable.

The two crews tried to visualize what was happening 60 fathoms below on the cutting line midway between them. The length of heavy anchor chain attached midway below was supposed to be working its way under the sunken hulk of the *Islander*. But every pull through was not a simple one. A hang-up or other

difficulty might call for an inspection by the bell diver from the *Griffson*. But as repeated pulls taught them how to interpret tension, direction, and positions of the cutting line, they usually answered their questions with solutions.

In retrospect, one needs to remember that compared to sophisticated equipment developed during and since World War II, the Curtis equipment and methods were frequently elementary and crude, making the project and its engineering accomplishment all the more unusual. The operation of threading the cutting line under a hulk partially buried in sediment of almost a third of a century at that depth was a feat of no mean measure, and 20 lines were 20 times so.

The early-day logging donkey was a symbol of timber operations. Those who remember donkeys and have heard their whistled signals and steam engine clatter can picture the operation of these screeching mechanical critters for our salvage job. In the woods the donkey operator signaled the choker setter with a whistle blast or two to stand clear. Then with his cable drum revolving furiously amid banshee shrieks and loud sounds of exhaust from the steam engine, he would begin bringing the cable-snared log up to the loading site. That the high line would frequently gouge holes in the hillside was of little concern in the early days of high line logging. That is what they had to work with to get the logs to a spot for transport.

The woods reverberated with the signal toots, the whine of the cables on the drums, the clatter of the engine. Those of us who have seen the engines of that period will not forget them. Here on the Inside Passage we had two of these banshees (for a while one gasoline driven) for pulling lengths of cutting line from the depths below—not with logs at their ends, but with a cutting tool being pulled back and forth under a sunken ship's hulk.

I suspect any old-time logging donkey operator would have been fascinated to see his familiar mechanical critter wheezing and whistling in the middle of an Alaskan waterway. And wheeze and whistle they did, but to the donkey crews on this job the word was not *fascination*. With occasional mechanical malfunctions and the problems inherent in pulling a cutting line blindly in the depths, the donkey crews quickly lost

any fascination they might have had at the start. Four-letter words were common. The fish and whales that occasionally sauntered near us soon must have gotten the idea that this splashing and screeching was a no-trespassing area.

Repeatedly, the cutting line—the heavy anchor chain—had to be slipped under the two propellers and dragged to an appropriate position under the hull of the *Islander*, each donkey engine operator touching the throttles gingerly the first few times. After the first line was threaded under the *Islander*, the crews knew their positions better.

Threading the lift cables onto the cutting lines was to be accomplished by pulling each cutting line topside and shackling it to the lift cable each time. Then, pulling the lift cable under the hulk and up the other side, the lift cable end was to be attached to one of the lift winches on the deck of the *Griffson*. First, however, the lift cable was brought over a dolly at deck level on the opposite side where most of the lifting strain was to bear. Thus, the cable to be brought up on the port side and over dollies would be attached to winches on the starboard side, and vice versa. Later during lifts, the *Griffson* deck was lined with the taut, heavy cables fairly singing under their strain.

For a time it seemed that Murphy's Law had cast its spell over us: "If anything could go wrong, it would." The gas engine donkey was not holding up under the strain and was under-powered for the grueling job. It would be better if both engines had been steam-powered from the start, for the cushioning effect of steam cylinders with their extra peak power and heavier gears was what was needed for the job.

The clatter-clatter of the donkeys and the alternating toots echoed across the Passage day after day. Finally the gas engine gave up the ghost.

But in late July and early August, a diversion occurred that briefly gave the crew something else to talk about. The S.S. *Northwestern*, Alaska Steamship Company's big tour and transport steamer, hit Vanderbilt Reef, a rock about 35 miles north of the *Islander* site. To save her and the passengers, Captain Livingstone beached her on Eagle River Bar. The closest help was Brownfield's tug, *Georgia*. At night at high tide on August 3 we

attempted to free the *Northwestern*. The hole in her bow had been temporarily patched while on the bar. It was a drizzly evening when the smaller tug *Akutan* from Ketchikan joined us alongside the bulk of the *Northwestern*, setting high on the bar. We had arrived at 6:30 p.m. with timing to take advantage of a rising tide. The snow-covered peaks grew red, then cold blue in the evening light in the distance.

A hail from the *Northwestern* to the *Akutan* at 8:30. At 9:00 the *Akutan* tied up amidships to the *Northwestern* on the port side, her bow toward the *Northwestern's* stern. At 9:30 a hail for the *Georgia* to come alongside starboard. The crew tightened the tow line to the bitts.

At 10:30 a hail from the bridge: "On deck, *Georgia*! Half speed ahead!"

From our wheelhouse Captain Rose: "Yes sir!" To our crew: "On *Georgia*! Half speed ahead!"

Our engine throbbed, but our stern was aground. We draw 13.2 feet while the *Akutan* draws only 6.5.

"On deck *Georgia*! Full speed ahead!" Our stern came free.

George Busby, our engineer, gave her all she had. The pull of the bigger *Georgia* swung the *Northwestern* slightly against the smaller *Akutan*. That was probably what was needed, for the seesawing of the tugs worked the *Northwestern* loose, and with her screws thrashing foam she slid off the bar.

Both tugs were going full speed, but the engineer of the *Northwestern* was afraid to give her full speed because of the possibility of a shaft being out of line. It seemed like the distant beacon lights were moving, but it was actually the big ship moving.

"*Georgia*! Cast off lines!"

"Yes sir!"

At 10:47 the *Northwestern* was off the reef and the *Georgia* was asked to convoy her to Juneau. But a water scow loaded with fresh water that had been brought up for the *Northwestern* had to be lashed alongside the *Georgia* for tow to Juneau. Tow was started at full speed, but the loaded scow almost dived with the speed. One bell was sounded and Engineer Busby threw controls over to stop and the scow righted itself. We

spent an hour pumping her out, then hurried to catch up with the big ship, whose lights had disappeared in the distance.

Catching up with her in Juneau harbor, we divested ourselves of the scow and helped the *Northwestern* dock. The *Northwestern's* Captain Livingstone was exuberant. Recalling the loss of the *Princess Sophia* with more than 300 lives in the very same area that snagged the *Northwestern*, I felt great satisfaction in seeing another ship escape Davy Jones's Locker.

Replacement of the gas donkey was an immediate problem. Contact was made with a logging and lumber firm to rent one of its steam donkeys at Snow Pass, south of Petersburg. So after supper on the day following the *Northwestern* episode, the *Georgia* headed out for the 20- to 24-hour trip to pick it up.

Almost three days after leaving, the *Georgia* returned without a donkey. Object of the trip was really on an immense raft of logs, high, dry, and unreachable.

On the way back, however, crew members saw another steam donkey on the shore of an island near Wrangell Narrows. Going ashore to inspect it, they were met by Miss Olive McCarter with her 30.30 rifle.

"Hold it right there," she admonished the awed trio.

"We just wanted to look at your steam donkey, ma'am," said Dick Kohler, who explained their needs and who they were. It turned out she ran the fox farm on the island all alone and obviously was a little skittish about strangers. She quickly became friendly when she understood who they were. However, the donkey was not operable and the *Georgia* came back empty-handed.

A week later, on August 11, the MS *Northland* brought a big Star Machinery winch and engine to serve as a new donkey. It also brought some watermelons with the supplies. Oh boy!

Throughout the summer and fall of 1933, we were anchored immediately adjacent to or in steamer lanes in the Passage. Notices had been put out on all shipping communications of our presence, and regulation lights and buoys had been displayed. Despite these precautions we had a few close calls that occurred when visibility was poor on foggy or stormy nights.

Early on the job some ships glided by so close that we wondered if the pilots were aware of our actual location. Concern was felt for our cutting line scows, particularly the one on the port side, the side facing the steamer traffic lane.

Shorty commented, "Maybe somebody will have to be salvaging us."

I recall vividly that night about 11:00 p.m. There were no night shifts, and all the crew had hit bunks after a long, hard day. Everyone was asleep except myself and the night watch, and he was probably in the warm boiler room in the bow of the boat in between trips on deck.

I had been doing a little after-hours work in the darkroom and had come beside my bunk preparatory to getting some sleep. The porthole was open for ventilation, and I heard the subtle but unmistakable sound of a big ship's bow breaking water. Looking out, I saw the well-lit, massive bulk of one of the big steamers passing only the length of the *Georgia* away. Too close! Did he know about us? Well, I hoped he knew now!

Even though he had missed us and apparently an outlying scow with its cutting line, there was still a chance he might run afoul of one of the *Griffson's* anchor cables. I pounded on Shorty Curtis, asleep in the lower bunk, then raced up on deck.

There I saw the shape of the passing steamer's stern. No one was visible on her deck, and I wondered how much the pilot and the bow watch had seen of us. As her running lights faded through the ghostly fog in the distance, I turned with a feeling of sincere relief and headed below deck. I met Shorty, putting on his pants. I answered his grumbling query of "What the hell is going on?" with an explanation. We both agreed it had been too close. The *Griffson* wouldn't last much longer than a bunch of kindling wood if the steamer hit us.

Pilots and ship operators had been notified of our location in the ship channel in the Passage, and we always had necessary lights visible. Apparently, someone hadn't read the notices. The next day Curtis telegraphed several reminders of our position to shipping offices.

When it came to developing negatives in the darkroom, quality control went out the porthole. Water could be provided at the right temperature at the start of development, but when the nights became colder,

the developer quickly cooled. Timing became only an educated guess, and washing became more of a rinsing problem.

Above us on deck a heavy steam-operated anchor winch had been used to pull on anchor cables, and the vibrations had caused deck seams to split and allow some water to come into the darkroom. Using some tar paper overhead, I kept the darkroom work area dry. Later, however, the scratching and scrambling of little feet told me that rats had selected the tar paper for their travels. It was disconcerting in the dark.

The familiar horn and characteristic punga! punga! punga! of a big marine diesel interrupted our breakfast the morning of August 6.

"The *Norco's* here, you guys!" yelled Blair Headrick, as if most of us hadn't already suspected it. "Last one out has to smell my dirty socks!"

Coffee cups were hastily emptied and plates cleaned of Dave Olmstead's bacon, eggs, pancakes, and whatever. The arrival of the little motor ship with its special cargo was a break

MS **NORCO** BRINGS THE LAST OF THE LIFT WINCHES FROM SEATTLE TO THE **GRIFFSON**. ADDITIONAL LIFT CABLES ARE BROUGHT ABOARD.

in our routine. Perm headed for the cargo boom winches; Blair, Cliff Johnson, Dick Kohler, and a half-dozen others headed for the rail where she was siding for a mating with the salvage ship.

Though she carried no mail for us, she did have a special packet for Curtis—reels of heavy lift cable and timbers to add to our supply and complete the amount needed for the job. Additional bumpers were dropped alongside the *Griffson*, the ends of two heaving lines landed on the *Griffson* deck, and in a few minutes she was securely snugged, fore and aft, to the lift ship.

Stop of a visiting ship, even though brief, was indeed an occasion. Some of us from both the *Griffson* and the *Norco* gathered along the unused rail areas to visit. One on the *Norco* was Sigrid, who, bless her, handed several of us some fresh taffy—real taffy!

An arrival to our crew from the *Norco* was Irvington Clithero, who tossed his duffle bag over the rails and joined it aboard the *Griffson*.

Weight of the cable was a test of the remaining good cargo boom on the *Griffson*. One aged boom was under repair after snapping off during one of the preceding lifts, and Perm and the others held their breath as the heavy spools of cable were landed on the *Griffson's* cluttered deck. When the *Norco* pulled away, realization of the work entailed in getting that pile of heavy steel wire under the *Islander* began to hit the consciousness of all the crew.

For several days the *Griffson* swung in her anchored harness with the flow of the tide; she listed to port with the extra weight of the cable. The distribution of the cable and stringing on winches was a slow process. As the cutting line crews progressed the length of the sunken hull with their sections of anchor chain, the whistling grew more frequent, an indication of progress and confidence.

"We're on a toot now," commented Shorty.

Morale seemed to be improving.

. . .

Chapter Ten

Hooking the Big Fish

Smiling faces and hopeful grins looked at me from the photos I had taken of the crew at the start of the trip. A cheerful lot they were then. Two months later their mood was a sober one. The problem confronting them seemed for the moment to have no good answers, and the long hours and grueling work made it hard to smile. The succession of setbacks during the first efforts to wrestle the Old Man of the Sea had thrown some to the mat, but they weren't pinned yet. Dogged persistence and ingenuity overcame the urge to quit.

"I guess the guys on the Chilkoot Pass and in the Klondike had their problems, and we've got ours," philosophized Leo Blenssner. He and I were blocking up the foundation of one of the winches torn loose by a cable line pull. Leo was from Portland as was I, and we had developed a friendship from the start. He was a carpenter and a solid, hard-working family man, not inclined to talk much and seldom to cussin'.

His comment and the resulting conversation between us then centered on the similarities of them and us. Our common cause was the search for gold, but differences seem plain. Ours was the challenge of an engineering job—the challenge of the sea.

Almost two months of uncertainty had elapsed before we drew the first line under the *Islander*. Then in August a series of breaks and other problems plagued us. According to my log book, August 15—the 32nd anniversary of the *Islander* sinking—about 1:30 a.m. found the area fairly clear, but by 9:00 a.m. the fog had closed down like a blanket. Timing of the fog buildup was similar to that of the morning of the sinking. On our morning the S.S. *Alaska* passed us with repeat blasts of her hoarse-sounding whistle. By August 17 cutting began for the eighth cutting line, which was pulled through early the next day on Kohler's shift.

AN EARLY CASUALTY OF THE JOB—WINCHES TUMBLE INTO THE HOLD.

Chapter Ten

As the *Georgia* pulled alongside after a trip to Juneau, I noticed that a couple not in the deck crew had managed a break. The engineer and the bookkeeper were gleefully drunk.

When I finished my 12-hour shift on one of the cutting line donkeys, I tried to catch up with some work in my little photo darkroom until the wee small hours—a perfect way to become a zombie.

During a preliminary lift the next day, we noticed a winch supported by a timber-covered hatch jumping up and down as the brake rendered or slipped some cable. All hell then broke loose as the two winches collapsed their supporting timber platforms and tumbled into the hold. Broken beams leapt into the air and winches changed sides. Work was immediately begun to clean up the carnage and put in a stronger support for the winches. Good thing no one was underneath the area at the time!

Sunday, August 21, was a work day like the rest of the week. At about 10:00 p.m. the day wasn't done yet. Shorty was in the lower bunk, had just finished reading a dog-eared copy of the *Police Gazette,* and was about to pull the covers over his head. I had finished some entries in my log book at our makeshift table and was pulling off my boots when the air horn of a nearby motor ship rent the air. What the devil now?

The clangety clang of the gut hammer just outside the galley overhead was next—an obvious signal to rise, even if you didn't shine. As we pulled on our clothes and rain duds, the familiar noises of a vessel bumping our port side, shouts, the thump of the end of a heaving line, and the sound of a vessel's diesel motor quickly reversing itself came from above and through the porthole.

Deck lights of both the *Griffson* and the visiting vessel revealed, through the pouring rain, that it was the *Norco* again. Her shipment for us was 25 lift winches, some groceries, and other supplies. Our crew all turned out for the transfer and to put the stuff in appropriate places. The chore was done by midnight, the *Norco* was untied, and she chugged away.

"By damn! I'll have some more coffee," said Leo, as he and most of us filed into the galley and tossed our dripping slickers on nearby benches. We were tired and coffee didn't long delay our heading for our bunks. In another 30 minutes all was quiet again.

Curtis reduced the double shift work period to the length of one regular shift a day for the next two days while the equipment was being sorted and the crew gained a little strength during the sorting of the winches.

Slower progress than planned the first two months on the salvage job hurt the timetable for recovery, however. At the time I gave little thought to what lay behind the trips Curtis and the timekeeper had made to Juneau on the *Georgia*. Communication between Alaska and the Outside was by means of the U.S. Army Signal Corps Washington-Alaska Military Cable and Telegraph System (WAMCATS). Even the news agencies funneled their dispatches through the telegraph operator's key.

No doubt some lengthy and interesting messages must have passed back and forth between Frank and his associates in Seattle, which sometimes took most of a day. Waits were tedious between them. The contrast between that kind of communication and the radiotelephone Direct Distance Dialing now is difficult for some to realize. Knowing the financial problems of the day and the problems of our project, I find it easy to visualize the emotions in some of those messages.

(The story of the Alaska communications system is a fantastic one. Congress funded WAMCATS on May 26, 1900. By December 1931 all military and commercial communication between Alaska and the Outside had changed from cable to radio. It has been said that to jump from the Stone Age to the Space Age in less than a half-century in a country covering a rugged area one-half the size of Europe is a feat of no mean proportions.)

Our salvage operation was unlike the old galley ships where the tempo of the drum beat could be speeded up to meet the crisis of battle. Ours was more of a measured, though straining, pace. The only way to gain on the calendar, Frank decided, was to work longer hours each day while the Alaskan summer lasted.

By August 23 Curtis had renewed shifts of 12, in some cases 17, hours when on a good day the crew made a short test lift with eight of the nine lines. However, these shifts were too much of a strain on the men and didn't last long.

August 24 and 25 brought beautiful weather. On the 25th one of the guide lines to one of the lift cables brought up a pair of men's trousers it had snagged. The creases were still in them. Apparently, for our cables

to have caught the trousers from a passenger's suitcase or closet, the structures of the staterooms must have spilled or collapsed overboard and alongside the hull.

Problems with the rudder shaft on the *Georgia* sent her to town convoyed by the *Undine;* the *Georgia* was replaced by the *North Light,* a local fishing boat chartered for several days. Then on August 29 one of the lift winches broke a counter shaft on a short lift because of poor support.

A past master at practical jokes, Perm suddenly handed me the controls of a cargo winch while it was in operation with a small load. I was not familiar with them and handed them back in a hurry, the load meantime traveling slowly in midair across the decks. I felt like a jackass at the time, but shortly afterward I operated a similar pair

BRINGING OVER THE FIRST LIFT CABLE.
NOTE THE BRAKE ON THE WHEEL.

83

without such an abrupt introduction. I told Perm I had to check my pants that night after that little experience. However, he assured me that he could have retrieved the controls at any time before anything happened to the slow-moving load. Inasmuch as he had, I responded that it was a good thing. Ha! Ha!

The *Georgia* returned on August 30 and the *North Light* was discharged. The trouble had been only a broken pin on the rudder shaft near the quadrant. Little things can cause big trouble.

Kohler's crew brought the 10th lift cable around early on August 31. Late that night Curtis's crew in which I was working brought the cutting line back to within four inches of placement for the 11th lift cable. The next shift threaded the lift cable through, and the next day Curtis's crew brought the 12th around.

We changed back to the original cutting tool, or cucumber. The chain had done its job clearing the mud and debris from under the stern of the *Islander's* hull. Inasmuch as the chain was more difficult to move and the cucumber now could work its way easier and more quickly, it was logical to use it again. The preliminary test lifts had also helped to get additional lift cables under the wreck.

Optimism prevailed by September 1 because of the improved progress, and I heard conversations about putting the *Islander* on the beach in the near future. But the optimism was premature. The 11th cable broke in two on September 2 and was wound up. Perhaps it was cut or frayed by the cutting tool itself. The north wind began to blow and the housing on the large scow *Bremerton* was blown off. During the next 48 hours the wind portended winter.

First-of-the-month paychecks arrived when the *Georgia* returned from Juneau. My take-home for the month was $13.28 after deductions for stock and other things. All members of the salvage crew took part of their pay in bonus stock. Although I was signed up for half-time with the crew and the rest on my own as photographer, most days I was working full shifts or more. On September 4 my sleep was cut to less than two hours.

On September 6 a Union Oil scow arrived in tow of the *Lorna Foss* and discharged 600 barrels of fuel oil in the *Griffson* tanks for *Griffson* and *Georgia* use. Captain Brownfield returned from Seattle and Captain Rose and Engineer Busby departed, to be replaced by Hughes and Garfield.

CHAPTER TEN

FORTY OF THESE "IRON MEN" LIFT WINCHES ON THE DECKS OF THE **GRIFFSON** TO HEAVE THE **ISLANDER** FROM HER RESTING PLACE.

BLAIR HETRICK CUTS OFF THE LOOSE ENDS OF A CABLE BEING READIED FOR THREADING UNDER THE **ISLANDER**.

The following Saturday evening most of the crew went to Juneau to have the night off and dispose of some of their paychecks. Some went to a dance, but my clothes were in bad shape so I floated around with Ernest Hughes, *Georgia's* new mate and potential skipper. We ran into Cap Hayes and another member of the crew.

"Come along with us, boys," said Cap.

So along we went in the back door of a west end house. We chewed the fat and drank 3.2 beer until time to go. Prohibition had spawned numerous "private" taverns.

By the second week of September it was decided to use the anchor chain again for the cutting line. The forward portion and bow of the *Islander* were still down in the mud and debris of its resting place. Then we had trouble with the 16th lift cable and had to replace it. In ratcheting up its pieces on the two winches, John Mattson and I were convinced that it was plain hard work, besides being tedious. I am sure we would have appreciated the automated compressed air units that were used by others on these winches after the *Islander* job was over. By the end of the salvage job, the tides had raised the *Islander* and the crew had raised thousands of feet of lift cable from Stephens Passage waters onto the lift winches.

On September 15 we had good weather, but the main shaft of one of the donkeys broke, and the day's progress was zilch. So the next day Brownfield suggested sweeping the cutting line under in place of the donkey pulling it. Curtis was dubious but we gave it a try.

Brownfield took the wheel of the *Georgia,* with Kelly Garfield and the boys at the towing winch unreeling the line. Finally we tied up the *Georgia* alongside the scow *Bremerton* and sawed the line back and forth with the towing winch and the remaining donkey. But it apparently got hung up on the keel of the *Islander;* it didn't progress as it should.

The next day we tried another sweep with the *Georgia*, and the line was put on the lift winches late in the day. Kohler and Hetrick spliced eyes on the ends of the line, a time-taking procedure.

The *Georgia* swept a second line around the bow of the *Griffson* by about 9:00 p.m. on September 17, starting from the steam donkey and anchoring at the *Bremerton*. Here we waited for high tides at 11:43 p.m., during

which a short lift was being made for insertion of the new line under the Islander. But something discouraging happened. Brownfield didn't say much, but I could imagine what cursing was being done on the *Griffson*. Four lift cables peeled off from their winches with an ear-splitting racket. One cable and a falling dolly cut loose the *Undine* tie-down, and the drifting gas boat had to be picked up. What a helluva situation.

On the morning of Monday, September 18, the crew was a sober bunch. Work was begun immediately to take out the broken cables. The *Beloit* went to town with the broken gear for the donkey, and Curtis sent a wire to Hansen for 10 new cables. One of our problems was that we had both old and new cables with uneven stretch between the old and the new.

During the day another cable was lost because of being frayed earlier, and Curtis and Brownfield went to town in the *Beloit* and found an answer from Hansen. Ten additional cables were not available immediately, so Curtis had to settle on five and do some splicing on the ones we had. To even up the load on the cables, we decided to shift them aft on the *Griffson* to match the weight of the *Islander,* which should make the buoyancy better balanced and the hulls more even. The cables that had broke were at the points of longest distance during the test lifts. Wrestling with the unruly steel springs while shifting was no easy job.

During the brief periods between activity, Cap Brownfield and I had a chance to talk. He told of his sailing-ship days and numerous experiences, which included sailing round the Horn and sailing the Pacific. He recalled a typical incident close to home and similar to many others of the time. "John Gunderson and Morton Levy, they were saloon keepers who made me a proposition," he explained, puffing on his pipe. "They hired me to recover sailors who had been shanghaied. The only trouble was they turned around and shanghaied them for another ship."

The weather, always a fickle element, gave us a big rainbow the evening of September 19, then a red sky to the west. But, contrary to the old saying "Red sky at night, sailor's delight," the barometer went down noticeably the morning that followed. A mild southeaster set in, an indicator of autumnal change.

I went to town on the *Georgia* and got a bit more experience at the helm as well as experience loading coal—10 tons of it! Kelly Garfield, a tugboat man with a background of working for Standard Oil, the U.S. Bureau of Fisheries, and others along Alaska's lengthy coast, recalled a few of his experiences. One of the most harrowing was being trapped between the force of a gale and the ice from Malaspina Glacier. As a pilot of ships and holding a master's ticket for tug boats, his coastal travels surely did accumulate experience.

By September 21 a chilly wind was blowing and a fresh blanket of snow was on the peaks. All hands were out early to tighten the lift winches. (By now some called them "those dirty winches!") I then went out in the *Georgia* and helped during picking up of a lift cable— one of the busted ones. While we were out we heard a loud clatter from the *Griffson* and saw a cloud of dust and lines flying. Someone yelled, "There goes a hatch!", believing a winch had broken through. We found, however, that each of two lift cables had one end loose.

We carried out two kedge anchors on the *Georgia*, dropping them in line with the intended move toward Admiralty Island. Meanwhile, a westerly wind built up and began slapping us in the face with cold salt water from the Passage. It was with relief that we finished our chore and Brownfield headed us back to the *Griffson* in time for some lunch and hot coffee. Later that afternoon Hayes in the *Undine* brought some welcome mail that had arrived in Juneau on the *Northwestern*.

On September 22, with an additional line swept under by the *Georgia* we undertook a heavy test of the lift gear. Curtis ordered the winches taken up about two hours before the height of an 18-foot tide. When we could no longer ratchet them in high gear, we ratcheted them in low gear and cinched them up.

For about an hour all stood by and cinched them up evenly as the tide rose, then gears were dogged and all stood aside anxiously and somewhat breathless after working the ratchets together. I left the crew and set up the camera atop Curtis's cabin, anticipating almost anything. Eerie squeaks and groans from the supporting timbers spoke of the tide's lift.

Nothing happened. They stood the test fine as the *Griffson* went down to the 6.6 mark. As the tide subsided, we let out the winches for the night, and the *Georgia* swept another line under before the end of the day.

SUNKEN KLONDIKE GOLD

The next day a short lift was repeated, and because of equalizing the lines there was a minimizing of "rendering" or slipping of lines against the brakes in the first part of the lift. Gears would be dogged or locked as the lines were evened up.

. . .

WE GOT IT BY THE TAIL, BOYS! A TIRED CREW TAKES TIME OUT TO POSE WITH AN UNRULY CABLE END AFTER THREADING UNDER THE **ISLANDER** AND BEFORE WINDING ON A WINCH. CURTIS (FROM LEFT), HAYES, SHORTY CURTIS (IN FOREGROUND), KOHLER, JOHNSON.

Chapter Eleven

The Big Lifts

Certain galley supplies were getting low, some engine room supplies on the *Georgia* were short, and we needed photoflood bulbs for the diving bell's floodlights, so a trip to Juneau was set. The rain was a September rain, and the wind was kicking up a few whitecaps when the *Georgia* pulled away from the *Griffson* at 7:30 the next morning. With a chance for a turn at the helm offered to me, we set our course for Gastineau Channel in quiet anticipation of a shore break from the routine of the past weeks.

The tide was at an ebb when we secured the *Georgia* to the pilings of the Juneau docks, and our return was set for the afternoon. I climbed the 15 feet of algae-covered ladder with several objectives in mind. First, I would visit the office of the local newspaper and then run some other errands. The five others on board were heading in various directions, including finding sources for the supplies.

Elmer Friend was the news editor of the *Alaska Daily Empire,* Juneau's newspaper. He also was the Associated Press operator and correspondent in this capital city. Bob Bender, son-in-law of Alaska's Governor Troy, was the editor. Bender I met later, but Elmer and I were soon on a first-name basis after I revealed I had served some time as a cub reporter on a Portland daily and was involved from time to time as a stringer for several news agencies and newsreels.

"I guess you would know what's going on around here if anyone would," I commented.

"Whatever's fit to print and some that's not," he answered with a grin. "And Sammy Morse's invention is the gate that gets it in and out of here."

The medium of communication with the Outside was the U.S. Army Signal Corps telegraph system. Compared with the ease of radiotelephone contact with major Alaska centers in the 1980s, the old Morse code

telegraph key now seems laboriously slow. So it was. But speed is only a matter of comparison. The clickity-clicks of the key or teleprinter was a sweet sound indeed.

Troy had been the owner of a newspaper in Skagway, and news traveled even slower then. Major portions of the news were carried by word-of-mouth by passengers and crews of coastal steamships. Elmer was a veteran newsman who recalled the events of the *Islander* sinking, their effect on the headlines of that day, and the stories that followed. He was intrigued by the work of our salvage crew, as were most of those in Juneau at the time.

"No news yet," I conceded, but inwardly hoped there would be some soon.

A visit to Winter & Pond, local commercial and scenic photographers, produced some number 2 Eastman photoflood bulbs for our diving bells. For myself I picked up a few items for my photo cubbyhole aboard the *Griffson*. The visit also brought out the fact that the photos of the *Islander* before its fatal sinking (and used in this book) were taken by Mr. Pond himself.

With this photo information in my thoughts, I headed "uptown" for a local beanery. The toe or tip of the old tailing pile from the Alaska-Juneau mine rose on the right, the cold storage plant and docks were on the left, and scatterings of the red-light district showed along the way.

En route Charley Hayes and one of the crew emerged from a dockside alley. Said Charley, "I want to treat you guys to some of the best beer in town. Follow me!"

Against my weak protest that I had another errand to run, Charley insisted that we were his guests. In a modest storefront-house we were served illegal (this was still the Prohibition era) but good Alaska beer, which helped to improve my lunchtime appetite.

With mail, 300 feet of half-inch rope, forty 8x10 timbers, some lift winch parts from Seattle, five drums of fuel, and miscellaneous supplies, we headed back to the *Griffson*. Against the incoming tide and the wind-driven chop we rounded Tantallon Point headed for forlorn- looking home midchannel in the Passage.

In 1933 the States may have been known for several things, including the dropping of the gold standard

and the rise in gold market prices. But in southeastern Alaska on the *Griffson* we were generally oblivious to the effects of politics and the prevailing Great Depression. What was noticeable to us was that the weather was wetter and cloudier than usual. The U.S. Navy fliers assigned to photograph portions of the southeast coastal area, including Stephens Passage, called it a poor season for shooting oblique photos or selected air views. However, we webfooters from the Pacific Northwest donned our slickers and boots without a change of pace, the side effect being that the rate of sinus trouble for some of us hit a new high.

"Oh, dammit!" exclaimed Shorty one afternoon as the cutting line and its length of anchor chain fouled on a previously placed lift cable under the *Islander*. The air was blue with his expletives while forward and backward motion of the cable drums failed to clear the lines in the depths below. We sent the bell down again for a look-see. Another five hours' work replacing a cable and we were underway again, with the donkey engines whistling back and forth.

To those on passing craft, the lack of forward movement may have been deceiving. As Shorty put it, "It may have looked like we were just fiddle-fartin' around and actin' like we were spending government money."

But members of the crew were putting in some of the hardest work of their lives. Work hours were stretched to 12 to 15 for some shifts, and the work was frustrating. As signs of fall and winter imposed their none-too-subtle warnings, the atmosphere grew more tense. After breaking loose the sunken hull from the bottom, would the cables and lift winches hold up until beaching was accomplished? For that matter, would the *Islander's* hull hold together during the strain? Later, during the move to shore, we learned that her bow did break off. It was ruptured when it hit the bottom with its port side torn from the impact with rocks near Hilda Point (or, as the official report claimed, damaged by an iceberg). The separation came during one of the lifts, possibly midway to our destination of Green Cove.

Mail arrival by the *Georgia* or the *Undine* from Juneau, where it had arrived by Alaska Steamship or Northland Transportation Company motor ship, was always an important occasion. There was little in the way of other

communication in those days. Now that I think of it, there were no radios aboard, either. And in southeast Alaska there were no commercial radio broadcasters established until later.

How in the world did we get along, you might ask. Well, there were a few magazines and books. But after a long shift, often in the rain and wind, the guys were so tired they didn't do a lot of reading.

My mail would be an occasional shipment of photo supplies, some newspapers and magazines, an occasional letter from home, and once in a blue moon a letter in feminine hand from Corvallis where the writer, a deputy county clerk, would report on that area. Even after our 50th anniversary we still read some of those letters; they are reminders of the depression circumstances of those days.

The crew's morale during trying periods was buoyed by Curtis's men from his moving company. Their rapport with one another and their understanding of the boss held things together. An all-new crew might have been thrown into disarray, but as Perm commented, "This depression has thrown us all in the same pot. We just gotta crawl out of it together!"

An all-seamen crew would have been a misfit. Though on a water platform, the job required equipment for a big lift. The clutter on deck, which improved as the job proceeded, got by because we were not on open sea. But other problems existed, including winds and tides, the latter at times moving like a mighty river. The greatest problem was the clutch of the dark depths onto our quarry below us.

Frank was hard of hearing, and when he spoke his high-pitched voice was often projected to a level that he himself could hear above the noise of adjoining activity. Someone said that he had occasionally driven around Seattle in low gear because he could not identify the increased noise of the motor. On the salvage job his hearing problem was frequently more noticeable; he considered his hearing aid a handicap and a nuisance to his bounding around from place to place.

Food was important to keeping up morale and for stoking our human engines. Our cook, Dave Olmstead, was able to dish it out, along with a good helping of cookhouse banter. One morning as the healthy helpings of pancakes, bacon, eggs, ham, prunes, and coffee were reviving us, something seemed to be different.

"Dave," I asked, "what's special in the pancake batter today?"

"Oh, that's a special Alaska formula," was the answer.

Closer observation later disclosed that a section of burlap used for cleansing the griddle was also used for cleaning off some coal that had scattered when Dave fired up the galley stove. Dave blamed that on one of his galley slave helpers. But it was really an exception to the satisfaction we had with all the food. It wasn't fancy, but it was plenty of what was needed to stick to the ribs.

It was unusual for a breakfast to go by without our court jesters trading verbal thrusts. Blair and Perm ranked highest in their bunkhouse repartee, with possibly Si Hellene's dry Norwegian humor close behind. Among the other contributors was Cap Hayes with local color.

Our destination, Green Cove on Admiralty Island, aroused our curiosity about the island and its inhabitants, two-footed or four-footed. Besides Brownies, the big bears, it had several stills operating during the Prohibition days of the 1930s. If I may be forgiven for repeating the story, one was operated in a place called Kootznahoo Inlet. Its liquor was later called *hootchnahoo,* later shortened to *hootch.*

Though our salvage operation was far removed from the inlet, and to my knowledge any still's location, rumors did float in from time to time of moonshiners on the island. Hayes claimed to be on speaking terms with these gentlemen. I later became acquainted with Warren Harding (no relation to the late president) who was a Federal Internal Revenue agent. Harding on one occasion learned of an active moonshine operation not far from Juneau and set out to case the joint. The still was up a canyon wedged between two typical coastal mountains, and the trail was steep. The Alaskan brown bear is known as a critter that demands respect for its monster size and strength, and at a turn in the trail Harding was faced by a Brownie female whose two cubs were nearby. He received a severe mauling and survived only by playing dead.

At St. Ann's Hospital in Juneau two days later, he received a bouquet of flowers with this message: "Compliments to the bear, not you."

On September 24, with 12 good lift cables under the *Islander* and their winches dogged or locked, the crew accomplished another partial lift, the biggest thus far. On September 30 the last cable was threaded under. A lot of work had been accomplished.

The partial lifts, using only a portion of the tide's lift with only a part of the final 20 cables, served several purposes. First, they were a test of our gear and a reaction of our quarry below. Second, they raised the *Islander* somewhat from one end to gradually work her loose from the bottom; third, the lift enabled us to sweep more lines under her without the usual mud and obstructions.

During testing the stretch had been gradually brought to a common and stable point on all the lift cables in use. New cable thus was brought to the same stretch point as older cable, and they shared the load equally. Thus equalized or stabilized, they were locked into position by dogging the gears on the winches. Preventing rendering on the brakes apparently will prevent cable breaks.

More snow showed on the mountains, and crew members were not convinced they will eat Thanksgiving dinner aboard the *Griffson*.

On September 25, while sweeping another line under the *Islander,* the *Georgia* pulled the lift cable against the line to the *Griffson's* stern port anchor. The *Griffson* then swung in a wide arc, proving that the *Islander* was pivoting underneath. Possibly it was here or shortly afterward that the bow broke off, as we were to find out later. High tide was 15 feet 9 inches at 4:30 a.m. A partial lift put the *Griffson* down to 18 feet, the lowest since the last lines broke, with hardly a murmur out of the winches or cables.

Despite the serious work, practical joking was still alive. On a trip to town on the *Undine,* Curtis brought back some bedding material and a rug. When the rug came up on a hand line, Russ Clithero, on a humorous impulse, hid it. Accusations were directed at me, but I said nothing and went to my darkroom to do some work. Shortly afterward Carsten Knapland came in. "What's this?" he asked, referring to an object in a dark corner. "Gosh!" said I. "They've planted it here! Quick! They're coming down now. I've got to get rid of it!"

We figured maybe we could hoist it up through my porthole and to Cap Hayes's room; it seemed Hayes was the one who had planted it in my room. But I hadn't time, so I moved it to Cliff Johnson's bunk next door.

Perm came around quietly and unknown to me grabbed the rug; on the way to Hayes's room, he ditched it in Wilbur Wester's bunk. The cavalcade marched down the hall but was confronted by Frank Curtis. "Aha!" said Frank, and the joke was over.

Apparently the comedy was directed at the expected arrival of Frank's wife. She arrived in Juneau on the *Alaska* the following day and came out the next day on the *Georgia* to keep Frank company in the captain's cabin until the end of the season. Perhaps I was wrong, but it seemed to be more than a coincidence that her arrival followed closely on a fling Frank had in Juneau on one of his periods of frustration on the job.

Turning the frayed pages of my log books, which I recorded in daily, I am reminded of the weather, the aches and pains, and the groans and cheers of the crew as the days rolled by and the pages on the calendar changed.

> *29 September Friday 1933 - The crew found the water scow submerged and partially sunk from too many leaks. This makes a scow, two tanks, two work boats, and miscellaneous gear lost or out of commission. Two more lines were put under the Islander.*

> *30 September Saturday - In rain and wind, the last line was put under. The crew felt good but knows it is too early to celebrate.*

> *1 October Sunday - A beautiful day. The crew divided into sections, the town gang and the country gang. I told them I was just a country boy, but I got on the town gang anyway and worked on winches all afternoon.*

The partly submerged leaky water scow was located and towed to the bow of the Griffson. It was flipped over with a pull from the anchor winch, then towed to the beach to be caulked.

2 October Monday - It rained hard. Our town gang worked from noon until supper. We changed three lines from the poop deck to the main deck, a tougher job than Kohler's country gang, who moved five lines on the main deck. I handled the steam-powered cargo winches in the line shifts. Always a touchy job, it required plenty of TLC.

3 October Tuesday - Rain and wind. The last two cables were moved and the two gangs tinkered with the winches, which are numbered. The list of winches and men to handle them was posted. Mine: number 13.

4 October Wednesday - More rain; we each checked our winches—oiling, greasing, and repairing. Number 13 needed repairs and was welded. We took a light lift for the purpose of adjusting winches, setting them on brakes, then dogging them after adjusting. The wind got worse, and the Griffson bobbed up and down a bit when lines were loose and anchor cables slackened.

5 October Thursday - Saw heavy swells for this area and continuous rain; we were all wet before the day was far along. Cables and anchor chain were run out on the bow of the Griffson. Crew struggled to get ready for the high tide at 1:37 p.m., but gear wasn't ready in time to get full benefit. The bow of the Griffson was swung toward Green Cove at the flood of the tide.

In preparation for the next high tide at 1:36 a.m. and after a full day, everybody worked on through the evening after a few short breaks. Line on the bow anchor was held tight with the steam winch, and the *Georgia* on the starboard side was readied to buck the strong tide that was building on the port side of the *Griffson*.

CHAPTER ELEVEN

The banshee howls of the wind, the irregular swinging of the few feeble deck lights that pierced the blanket of darkness, the pelting rain—the stage was set for a windy night.

Tension was high as dogs were locked on wound-up winches. The *Griffson* settled, winches groaned, and we moved. Shortly after the peak of the lift, I went to bed but couldn't sleep, thinking of the weight on the lift winches overhead. At 4:30 a.m. I got up again and joined several others on deck. Wind still howling.

That same day, Friday, the storm subsided, sun peeked out, and two more lifts of 100 feet each were made. *Georgia* tied up alongside *Griffson* and gave each move all its power, the units on the anchor lines pulling in concert.

At this point Hayes went down in The Thing and came up with a startling report: The bow of the *Islander* was gone. Where it broke off, he couldn't tell.

Work days were lengthy and fitted to schedule of the lifts—no eight-hour schedule here for anyone. My half-days were more than full days on the deck plus a few hours snatched at night in the little darkroom.

7 October Saturday - At the end of two lifts, the beach was at least 300 feet closer. Bow and kedge anchors were carried forward and lines on them were pulled tight as the Georgia and Beloit pushed alongside. Stern kedge line on port side helped counter the strong push of the tide. One puncher for the steam donkey quit, disgruntled at long hours. Curtis hurt his leg from rolling chain while accompanying an anchor-changing crew on one of the scows. Confined to his cabin but treated us all to two bottles of 3.2 beer each. Crew in a jovial mood. Ray Clithero acted as ship's barber, and the boiler room where he was keeping up steam was his barbershop.

8 October Sunday - Dick Kohler reported that moves to the beach have covered a total of about 1400 feet on a gradual incline and that we used a total of 1000 horsepower on each move.

Russ Clithero, keeping track of winch winding, reported about 45 feet on each cable end has been taken up thus far since beginning of main lifts. Some high-powered cribbage and pinochle games frequently underway in the galley after supper. Curtis stayed in town several days to get hospital attention for injured leg. Brownfield, a hard worker, led the portion of crew. Days are darker, nights longer, and lights were on for breakfast and supper.

Alternating shifts took up the cables on the lift winches. As the men checked the winches and the tide rises, the usual noises of lines cracking and jerking occurred as the cables occasionally slipped or rendered on the brake drums. Dishes were shaken from their places in the galley, and the sleeping crew below was awakened by the noises. Cracks in the walls and deck overhead were more noticeable.

Heavy chop was now on the water, frequent and with chilly rain. No lifts were done on several days because of low tides. On those days the crew marked the lift cables and slacked each off about 10 feet, then secured them. Excess cable on the filling drums was cut off, which also eliminated some spliced and clamped ends.

Everybody had trouble with leaks into their bunks from cracks in the deck overhead, and my little darkroom was a mess. No serious damage to supplies, but tar paper helped to catch the drip drip from overhead. Members of the crew stretched old canvas over their bunks.

After the arrival of the mail, Cap Brownfield talked to me of his old sailing ship days when he came over to give me a couple of *Saturday Evening Post* magazines.

As we edged toward shore, we were careful to clear a submarine (submerged) cliff, which would be tough if the *Islander* slid over it. Early in the operation, the *Georgia* made soundings along the route we are to take. I was impressed with the judgment and character of Captain Brownfield, whose ability was contributing so much to the success of the project.

CHAPTER ELEVEN

15 and 16 October Saturday and Sunday - Lifts and the Griffson moved about 425 feet with its load. Rain and wind changed to colder and calmer weather with more snow on peaks. Winter ahead! A crew member who got in a drunken argument with me on the Georgia dropped around for a friendly chat now and then; the incident now forgotten. Weather is colder, wind raw and snow on the hills. Seagulls clustered in a fraternal gathering on the ship. Lifts shorter toward the beach.

17 October Monday - In two moves the salvage ship was closer by 1000 feet to Admiralty Island, but on October 18 it really moved. More than 2000 feet was covered! Dick Frary, the night watch, remarked that the moves almost brought them up to their kedge anchors.

Cap Brownfield was on the job, however. It was highly advisable to shift course immediately because of the submarine trench of about 1200 feet long and dropping about 240 feet deep near that point. The *Georgia* on a short tow line to the *Griffson* made the change. Now the snow-covered peaks to the northeast, which had been on the port side, were behind us.

The discordant chorus of the rattle rattle rattle of ratcheting winches sounded again in a before-breakfast warmup. "It'll scare the hell of the bears," I commented to Dick Tripple.

"It would scare me too if I didn't know what it was," he answered.

And it was true: In the dim light or darkness that strange sound would put the fear of the Almighty into any passing critter. No sound like it had been heard here before—probably none like it again.

Then, during the lift the *Griffson* slid like some huge black creature of the deep out of the night into the overcast gloom surrounding the island. The only sound was the pouring of water past the *Georgia's* crew and the gentle slicka slicka of her steam engine. As the tide went out, the *Griffson* rode the gentle swells, sheltered in the lee of Admiralty Island from the direct flow of tidal currents and the southwest wind.

Number 2 line got too full on the winch drum, and excess was burned off. The move to shallower water will require all drums to be emptied that way. The increased leverage of cable leading from a full drum also was a strain on the gears.

19 October Wednesday - Snow on deck and blizzards on hill. The Griffson now at right angles from its previous course as it heads for Green Cove. At night the wind increased to a gale. At about 9:30 p.m. the call went out: All hands on deck to slack off winches!

We didn't want to pull the "harness" from the *Islander* while we were plunging like a bronco. Loose cables would give more freedom. We were glad we made it to the comparative safety of adjacent Admiralty Island, even though we were still broadside the north wind.

But the next morning the crew got up shortly after 5:00 to take up slack for the next tide. Winds had died down and the day was clear and cold. Ice was on the gear and deck with about 18 feet of cable to ratchet on each winch. On the lift early that afternoon we moved more than 200 feet, and Brownfield said that the *Islander* now lies in about 31 fathoms.

On the evening of October 21 we were tightening up the winches when the wind began to rise. While we were working on the forward end of the *Griffson* where the slack was the greatest, on each surge of the ship the cables popped with an alarming sound across the deck.

As the cold wind from across the Ice Cap and Taku Glacier grew stronger, we hastily left the forward winches and collected in a strained group on the afterdeck.

"By God!" said Leo. "We've got to slack the cables quick before they bust!"

We were most of us in agreement. "Yea!" we chorused. "Slack 'em off and be done with it!"

"Hell!" said Russ. "We can't slack three of 'em up forward. We cut their excess off today with the torch and there isn't any slack to let off!"

CHAPTER ELEVEN

So there we were. We couldn't slack off the rest because in so doing we would break these three. There was just one thing to do—take them up and make a running try for it.

So we did. It was a hairy job, what with cables a'poppin' and the *Griffson* plunging like a wild horse. The little slack remaining at low tide limited the plunges, but every surge of the ship was concentrated on these brief lengths. Kerslap! Bang!

We had made the first winding of the after cables and were working on the forward half of the *Griffson's* deck when the howling storm laid about our ears in earnest. Half a revolution of a ratchet handle would be made on the winch, when bang! the *Griffson* would complete her roll to the other side and the cable on the winch would become taut. Ratchet handle and crew members would fly back the limit of the ratchet. This action would repeat itself on each side of the deck.

With the surging sea under us and the cables jerking on all sides, the winding of those last winches was an adrenaline stimulation. But as the tide came up and the cables began to tighten, we went over them—the few of us that would—and checked for equal tension and dogged the gears. The wild horse was harnessed.

Luckily, no cables were broken and no one was hurt. That night a fine move of about 200 feet was made on the lift pulling on the two cables anchored ashore. Afterward lift cables were slackened.

22 October Saturday - Broke with a strong Taku wind blowing harder, bringing the environmental impact of the Ice Cap from the mountains right down to us. The wind increased to what was later figured by weathermen in Juneau to be more than 75 miles an hour.

The wind-cursed water whipped its frothy invectives against the old *Griffson*. The surface of the Passage was a'boil, but not with heat. Beaten to a froth, the storm-flung waves turned to a ring of ice on the sides of the salvage ship.

As one crew member said, "It was a bit air-some!"

Another one quipped, "It's too damn cold to crap!"

And I thought, How in the bloody hell are we going to keep from freezing?

Most of the hands either huddled around the galley stove or climbed into their bunks to keep warm. Wind-blown spray froze on deck. The crew's bunks, including my own, were near the six after-lift winches. In spite of having released slack on the cables at low tide, the high tide periods still slapped cables against the *Griffson*. The up and down surges then were hard on the lift winches. We recalled broken cables and timber of earlier lifts, and the specter of winches tumbling into our bunks haunted us.

The tide receded late that night, and the cables eased up on the straining lift winches. With the wind still howling, we escaped to an exhausted sleep.

The *Undine* and *Beloit* were already in Juneau, and the *Georgia* had left the morning of October 21, Curtis aboard with his ailing leg. The 20 of us remaining crew members were left isolated on the *Griffson*, with its heating facilities entirely inadequate for the occasion.

Could the cables stand up under this pounding? we asked ourselves. Amidst the squeaks and groans on deck was the wind-blown tinkle of the bell outside the galley. I told Dave it must be one of the *Islander's* departed Chinese cooks ringing it.

The Taku wind howled for two more days. The *Griffson*, with a girdle of ice on its hull and its deck sheathed in ice, was well anchored, but its gear and sides had taken a real beating broadside to the storm. The *Islander* below was a good anchor but, we hoped, not damaged by the surging *Griffson* and the lift cables.

At the tail end of the storm, the sturdy *Beloit* brought supplies and galley coal. As weather calmed, I went ashore in a skiff to get some photos of the lift ship.

When we woke up the next day, about two inches of snow were on deck and more falling. As snow turned to rain, attention was turned to inspecting the *Islander* below. Diver Charley Huckins and assistant, Murray

Stuart, arrived from Seattle and prepared their suits and gear. The *Georgia* struggled to retrieve and reset some anchors; checking of lift cables revealed 210 feet have been taken up by October 29.

Repeated short lifts were made, and by October 31 the lift ship was in 12 1/2 fathoms of water forward and about 13 1/2 fathoms aft at low tide. On November 2 Huckins went down and confirmed the *Islander* was minus its bow section, and he walked from there to the beach to check the route.

But on November 3, after a short lift in the morning, low tide at 7:33 a.m. dropped the bow of the *Griffson on* the Islander, to the crew's surprise. The bow of the *Griffson* rose as if in a dry dock. Four cables unreeled on their winches with a shower of sparks in the dark, but we rode out the awkward situation. The *Islander* hulk stayed where it was, hanging on a slope of shallow water.

By the third week of November, preparations were made to hole up until spring. In anticipation of the heavy pounding winter storms would bring, all lift cables were dropped in snakelike coils alongside the *Islander*. The *Griffson* was anchored nearby, two watchmen were left behind, and the crew went south for the winter.

. . .

Sunken Klondike Gold

Gas boat **Undine**.

Chapter Twelve

The Demise of a Friend

If there were a heaven where gas boats might be taken—a calm, protected water in the Land Beyond where the ghostly shapes of faithful, chugging hulks might safely ride at rest— surely the ghost of the gas boat *Undine* deserves to be there now. For the *Undine*, may her memory be preserved, was like Old Dobbin, faithful to the last.

Survival of hard work, abuse, and numerous storms, not to mention many ill-meant kicks and strong invectives, the *Undine* was indicative of a stubbornness that probably places her on the roll of something or other apart from the ordinary. Parts of her were worn to a frazzle, her stern rail was entirely torn or sawed off, her decking was gouged and punctured, her house was daily in danger from ducking under outstrung cables. Yet she was still able to chug away heartily until a fierce Taku wind tore the very bitts out of her deck and piled her onshore in late December. Her scattered remains were tossed on the windswept beach of Admiralty Island at one edge of Green's Cove.

Far be it from me to let sentiment run wild on the oily memories of gas work boats. But let credit be given where credit is due. This memorial is dedicated to the memory of the gas boat *Undine* and its successor, the Pee Wee, and all valiant little gas boats whose fortune or misfortune it has been to be drafted in the cause of deep sea salvaging. May their work be remembered. And when the time comes to quit their chugging efforts, as did the *Undine,* may their weary hulls rest in peace.

The *Undine* had been put to work at jobs that only a boat of her small size could do. Did a line need carrying out? Get the *Undine!* Was some small towing necessary? Start the *Undine!* Did somebody need to go to Juneau? Jump on the *Undine!*

Oh, it was true she had her faults. Any gas boat would, if overworked and worn out as she was. The rebellion in her oily heart was perhaps a rebellion for rest. We members of the salvage crew could sympathize with her on that score.

One of her worst faults was the stubbornness of her water circulation pump. Charley Hayes, her captain and godfather most of the time, was laid up in the hospital in Juneau with bad burns caused by the explosion of one of the petcocks by live steam. After that the circulation pump was fixed.

So in this comment on the violent end of a little workhorse, left to endure the cruel Taku winter winds, we remind ourselves of our affinity to the *Undine*. Becoming closely associated with a mechanical thing on a job or just during part of our lives gives us a feeling of an associate—a partner. And so it had been with this little gas boat.

. . .

CHAPTER THIRTEEN

THE SECOND YEAR

The barkentine *Forest Pride* had been a beauty when all sails were set. Built before World War I, she had carried cargo—mostly lumber—up and down the West Coast and Pacific Ocean points. One of her bigger tasks was yet to come; her days were not yet over.

The *Pride* lay quietly alongside the wharf at Lake Union, Seattle. On her deck lay several long and sturdy logs. In her holds were stored some big timbers and smaller beams. What lay ahead was a job her builders had never foreseen, that of a companion to the *Griffson* in putting the *Islander* on the beach. In short, a truss structure was to be built with logs across decks of the two ships, with the Islander slung below and in shallow water. Then, with the boost from the tide, the two ships and their burden would be deposited on the beach where Captain Foote had wanted to go that chilly morning back in 1901.

In mid-April 1934, when the crew reassembled on the decks of the *Pride* and on the wharf alongside, it was with a sense of elation that we felt the job was nearing conclusion. Among the familiar faces was that of Frank Curtis, his shrill voice greeting us. With him was his son-in-law, Perm Waddell; Shorty Curtis, his nephew; and Ross Curtis, his brother. It was the same gang that ended the 1933 season, including his moving crew plus or minus several others. And there were four Clitheros instead of three.

Captain Brownfield, with his ever-present pipe, was gathering his tugboat crew. The tug *Georgia*, a marine workhorse for coastal and harbor waters, was alongside building steam. After depositing supplies I needed on the *Pride*, I carried my duffle aboard the *Georgia*.

CREW OF THE SECOND-YEAR EXPEDITION, 1934.

CHAPTER THIRTEEN

As we pulled out of Lake Union into Puget Sound, the beginning of the last phase of the *Islander* salvaging began. A junior crew member, I was to take my turn at the wheel under a man experienced with the Inside Passage, its vicissitudes, shortcomings, and advantages. Later I was to get a small boat operator's license for craft up to 65 feet in length, though for now it was a new experience.

Alaska charts in the early 1900s were incomplete, and even in 1934 they were not as thorough as they should have been. Later the U.S. Coast & Geodetic Survey, the U.S. Geological Survey, the Canadian and B.C. provincial agencies, and individual coastal mariners and pilots added new information for the busy use of coastal waters. In later years beautiful tour ships and numerous private craft and fishing boats traveled the B.C. and southeast Alaskan waters guided by radar and backup steering systems, their charts now marked in detail.

The small knot of friends and relatives who waved us bon voyage no doubt were thinking the same thing we were—that this was the year of the answer to the months of planning and effort. With the *Pride* lashed alongside the *Georgia*, we left the congested area at slow bell, later changing to a short towline. It was with a more relaxed outlook that we headed up the Sound with the towline at its standard length, and our bow took the bone in its teeth as we headed north. We left Seattle on Friday the 13th of April, 1934, but Brownfield and Curtis each had a clear conscience. Clearance papers had been filed for April 12, so we had no stigma of that bad luck tale.

With the exception of Charley McCallister as assistant engineer and, of course, Captain Brownfield as skipper, the *Georgia's* crew was a new one: Nick Curry, middle-aged first mate; Carsten Knapland, second mate; and Harry King and Richey Navarre, galley crew and helpers. Jim Hughes was chief engineer, Irving Clithero and Bill Lindley deck hands, and myself serving one watch as helmsman.

Six hours on and six hours off—that was the crew's schedule aboard the tug. The job was bolstered with frequent cups of black coffee from the ever-present galley stove. By the time we got used to the schedule, the trip was almost over. The *Pride*, with its slimmer profile, was not as much of a wind catcher as the *Griffson*

had been, and we made better time than our trip north in 1933. But it was no speedboat trip. There were times when one could visualize a view of the *Pride* with all sails set as she used to be when she was a lumber schooner heading up the coast in the open sea.

The morning was beautiful, and the steep, tree-lined slopes of the Inside Passage seemed like giant green walls protecting us from any problems of men or elements. A few fast-moving cumulus clouds traveled across the strip of blue high above us.

Carsten had turned the wheel over to me and was studying a chart when Brownfield came through the door of the tug's pilot house. A stretch of open water and a slight change of course lay a few hours ahead, and the two scanned the chart together, discussing some points of special interest. Then, since Carsten had been on watch for several hours, Brownfield suggested he might appreciate a cup of hot coffee.

After Carsten went below, as a prelude Brownfield tamped a fresh ration of tobacco into his pipe, lit it, and drew deeply. "I guess you know all about the Weyerhaeuser kidnapping."

WE HEAVE-TO EN ROUTE WITH THE **FOREST PRIDE** IN TOW.

CHAPTER THIRTEEN

I admitted that I had read most of the details of how the two children of George Weyerhaeuser had been held for ransom. The story was front page news only a short time previous to our first year's work on the *Islander* salvaging.

"Well, our backer has some kids too, and being as how he works for the same company and is pretty close to Weyerhaeuser, he is pretty touchy about the whole thing. As a matter of fact," Brownfield glanced down at his pipe as he continued, "that's one of the reasons he is gun- shy of any publicity, I guess."

His comments were meant to explain in a friendly way some policy changes that were to affect me.

"Of course there may be some other reasons for his not wanting news stories about the job," he added. "Some people think the deal is a gamble, and the Weyerhaeuser outfit is kinda conservative."

But he was sympathetic with my position and prior arrangement with Curtis. He indicated that in my place he would stand his ground and not be throttled in the release of stories when the time came because they would be public property anyway.

"You could do pretty well ashore or from a small boat after she were up," he commented.

I reserved comment, but I knew that my empty purse would, unfortunately, be a deciding factor to stay aboard, come what may.

I studied the course ahead while Brownfield reviewed the chart. He made some comments on several changes ahead, suggesting that he would probably take the wheel at that time.

As a tow we made fair progress, especially considering we had to wait for the tide before going through Seymour Narrows and wait for a squall to pass before crossing Queen Charlotte Sound. The trip, including waits, took seven days, and fair weather prevailed for the first three. During the whole time the battered coffee pot on the galley stove served the crew as fuel did for the *Georgia*.

Grenville Channel, more than 30 miles long, was as attractive as ever. We left it at Watson Rock Light and entered Arthur Passage, then Chatham Sound and Dixon Entrance. We crossed Dixon Entrance the following day, and it was raining when we anchored at Ketchikan at 2:15 p.m.

Porpoises played about our bow in Clarence Strait the following days. After a short wait for the tide we went through Wrangell Narrows nicely. As we went through the channel at Petersberg, we had some concern about our tow's clearance of a dredge, but with a shortened tow line and a little maneuvering, we passed it with no problem.

At 8:00 a.m. Seattle time on April 20, 1934, we sighted the *Griffson*. Everybody had had an early breakfast and all were on deck. The *Georgia* hauled in the tow line and was secured to the *Pride* with bow and stern lines. With Brownfield on the deck of the *Pride* and Carsten in the wheelhouse of the *Georgia*, the *Pride* was put alongside the *Griffson*.

The guard crew hailed us from the familiar rail. Eventually Cap Charley Hayes came alongside in a gas boat.

"Been hunting any more bears lately, Charley?" yelled Perm.

A few of our crew laughed. "I'll make believers of you guys yet!" he answered.

We asked the guard crew and Charley how the *Griffson* had fared over the winter. They admitted it had some bad moments during some of the storms, which had truly punished the old wooden hull. The precaution of dropping the cables alongside the Islander the previous November had been wise, for the wind-whipped, plunging *Griffson* would have shaken the *Islander* hull to pieces.

That day and in the course of the next three days, the *Georgia* made several trips to Juneau. Communications and picking up fresh water and fuel for the *Griffson* kept the *Georgia* and its crew busy. Shortly after our arrival, Brownfield returned to Seattle on the next steamer to attend to his towing business and affairs. The *Georgia* was left in the charge of a standby crew, and some of us moved back to *Griffson* quarters.

The winter had dealt with unheated quarters, as winters are prone to do. Those of us who had returned pitched in to air them out. Damp mattresses were put on deck to air in the sun. It would take a bit of doing to get back to normal. The rest of the crew returned to the *Griffson* when the sun and fresh air had done their work.

One of the first chores after anchoring was transferring 20 winches from the starboard side of the *Griffson* to the starboard side of the *Pride* alongside, a job begun on April 22. Twenty heavy-duty dollies also had to be transferred, and these were secured to the starboard edge of the *Pride's* deck to take the weight of the lift cables as they were brought from the *Islander* below and across the deck to the lift winches.

Firing up the steam boiler, running a check on the steam lines, and activating the cargo winches were accomplishments in themselves. Perm, Dick Kohler, Cliff Johnson, and Blair agreed with Frank when he said of the cargo winches, "After laying around all winter, the sonsabitches act like they don't have to work!"

The lift winches couldn't be secured yet. Logs had to be laid across the decks of both ships so they would act as one unit in beaching the *Islander*. We had brought several big logs from Seattle on the *Pride*, but these were only a beginning. The rest would have to be logged from the steep slopes of Admiralty Island.

Another problem awaited the crew. During the winter the *Islander*, resting on an incline on the island's submerged edge, had slipped down slightly over its cradle of lift cables, and the now-loosened cables had to be recovered and shifted. It was a tricky, tricky job. Recovering the 40 ends of those steel snakes that had been dropped to the underwater slope of Admiralty Island was a tough experience. The piled coils lay along the sides of the sunken ship. For a time it was a nightmare to the diver below and the riggers involved on deck overhead. Securing them was accomplished with the help of a specially constructed V-shaped hook that was guided into position by a diver in a conventional diving suit. Once settled in the hook, the end of the heavy cable was gingerly raised and shifted into proper position across a dolly and onto a winch on one of the two lift ships.

Charles Huckins, a Seattle diver, had been retained by the salvors to assist in this retrieval operation. It was a tedious process. Although not in the same category as the deep-water dives made in the bell by the other Charley, it had its moments of concern. In the beginning a coil of cable had a reluctant tendency toward not leaving the bottom. It would entangle itself with other cables, unwind the wrong way, or come up in a tangle and then unwind in a bunch. Huckins naturally made it a point to keep clear before giving the lift signal.

When Huckins returned to Washington, he told listeners there and in Oregon a dramatic story of his diving work on the *Islander* job, a story laced with other thrills of divers in fish traps and of all the hazards of diving in the Alaskan area. "Devilfish" or octopi, wolf fish, and sharks held terrors for the diver, Huckins told his audiences, but the worst he had encountered in the northern waters was the ling cod. "The face of a ling cod was enough to make my blood congeal," he said. "They travel in groups like wolves, and are quick as lightning."

Huckins knew a good story when he saw one, and because of his early return he upstaged Curtis, who was to return two months later after final completion of the *Islander* raising. Occasionally, he was even given credit for the salvaging. However, in spite of his dramatic presentations in small theaters, Huckins should still be credited with doing a difficult job on the cable retrieval. Like the rest of us, he was perhaps underpaid for his work but was one who took advantage of its publicity value.

DIVER CHARLES HUCKINS IS SUITED UP FOR A DIVE.

CHAPTER THIRTEEN

During the shallow water diving and cable retrieval, we were visited by two officers from the U.S. Coast Guard cutter in Juneau who observed and discussed the operation with Huckins and some of the crew. They reported to their superiors in Coast Guard headquarters in Seattle, who were interested in marine casualties as well as in our operation in a shipping lane.

U.S. Navy headquarters personnel in Seattle were interested in our project when I contacted them for a photographer's pass. Naval intelligence officers

Charley Huckins Goes Down
Leonard Delano Photo No 83

HUCKINS PREPARES TO INSPECT CABLES FOR RETRIEVAL.

117

asked that I act as their observer on the *Griffson*. At that time they were beginning to be more interested in deep sea retrieval and diving. Later they greatly exceeded the world's record depth for ship recovery than we were making. Of course they had much more going for them in equipment and men than we had in our effort.

In early May we conducted our logging operation on Admiralty Island through arrangement with the U.S. Forest Service in Juneau. Blair Hetrick, whose work in the woods before coming north had been with a Port Townsend logging outfit, took the leadership role in the woods on the steep hillsides of Admiralty. Trees were felled, trimmed, and cut to appropriate lengths with crosscut saws and muscle. Chain saws weren't in fashion yet. What was missing in equipment was filled in with manpower. A haul-back line got the tow cable up the slopes. Then the *Georgia*, with a cautious heave, would pull on her winch. Down would come the log—kerbam! The splash was spectacular, for the logs would come 500 feet or more down the hillside. They were rafted to the lift ships and put across the decks to supplement the larger ones brought from Seattle.

Putting these logs on deck was a procedure strictly unique to the Curtis operation. They were no dainty matchsticks, either, as accompanying photos show. When on deck, some were selected as central trusses and had to be hand-hewn of bark. Some were towed to Juneau where the Juneau Lumber Mill ran them through their saws to square two sides. Then they were shifted into position and towed back to the site.

This structure of logs across the decks was necessary to prevent the lift ships from capsizing during the final lift as well as to give structural support. The cargo booms and deck winches were kept busy maneuvering the slippery and heavy green logs into place. In today's market these logs would be choice stock.

Ten trusses were erected over the logs. Of these, then, four in the center were made of logs and three at each end consisted of heavy timbers from the mill. One upright pole or smaller log section was set midway up each side for truss support, and all were reinforced with ample banding of 3/4-inch steel cables. Spacing between the two lift ships was not much more than the beam width of the *Islander*, which was 42 feet.

CHAPTER THIRTEEN

When all logs had been positioned and before trusses were erected, timbers were laid running fore and aft over the port side of the *Griffson* and the starboard of the *Pride*. Lift winches were then reset on them with their cables running under the *Islander* in 130 feet of water.

THE LIFT-CABLE GRABBER: DIFFICULTIES FORGOTTEN; SMILES ARE HISTORY.

Sunken Klondike Gold

Coast Guard officers visit during a dive.

CHAPTER THIRTEEN

SHORTY CURTIS AND ROSS CURTIS WORK AT FAMILIAR JACKS IN SETTING LOGS.

Sunken Klondike Gold

Chips fly as logs are hewn for truss timbers.

CHAPTER THIRTEEN

WINCHES LINED UP ON LOG SUPPORTS.

FRESHLY HEWN TIMBERS RAISED FOR TRUSSES.

On May 3 Huckins made his first two dives in a regular diver's suit to the Islander to locate the dropped lift cables. He dove frequently after that until all cables were picked up and repositioned under the *Islander*. While the logging operations obtained logs for the trusses and lift support, diving and cable retrieval proceeded below.

To eliminate trips to town for water, a dam was constructed on a stream from Admiralty Island's nearby slopes and a pipeline and hose ran from it to a scow in shallow water. Here tanks were filled and taken to the *Griffson* and *Georgia* tanks, and *Griffson* steam boiler tanks were filled. Later, when the lift ships were on the beach, water was piped directly to them.

As if the project didn't have enough problems, the skipper and occasionally the first engineer of the *Georgia* began getting drunk when the tug went to Juneau for supplies and communications. On several occasions others of the *Griffson* crew who were aboard had to bring the *Georgia* back to the job site. On one trip the skipper slipped off the dock's ladder and missed the tug's rail by inches when he fell into the water. Luckily, someone was there to fish him out.

• • •

CHAPTER THIRTEEN

LOG SUPPORTS BEING PREPARED.

LIFT STRUCTURE BEFORE THE FINAL LIFT, SHOWN FROM THE **FOREST PRIDE** SIDE.

CHAPTER THIRTEEN

ABOVE THE WATER LINE! THE ISLANDER HULK ON THE BEACH AT GREEN COVE STERN FIRST BETWEEN **GRIFFSON** (LEFT) AND **FOREST PRIDE**. CABLE IN FOREGROUND GUIDES AND PULLS THE TRIO AT HIGH TIDE.

Chapter Fourteen

Up From the Deep

The two salvage ships, the *Griffson* and the *Pride*, flanked the dripping hulk of the *Islander* like two "auntie" whales with their calf huddled between them. The serene environment of Green Cove, Admiralty Island, ringed by the dense growth of green fir and hemlock, was anticlimactic to events that had led to the long-awaited finale.

Gulls eyed the beached trio with curiosity as their white and gray shapes swooped in elliptical sorties over the ever-widening area of mud. Crows denounced the whole procedure from tree to tree. Several Alaskan brown bears peered from hidden vantage points with superior, noncommittal grumbling. And wisps of remaining mist were fast dissolving in the July morning sun.

Mysteries from almost 33 years ago had emerged on that beach to be answered. Or had they? The next few weeks could tell.

The five men who peered over the rail of the *Griffson's* port side, like others of the crew, had been up for hours to watch the *Islander's* hulk emerge as the tide receded. Their thoughts must have traveled back to the discouragements that had plagued the progress of raising the famous ship. Etched in their memories was the job of recovering the lift cables that had been dropped from the lift ship the previous November. Before that was the series of discouraging lifts when cables unwound or broke and had to be recovered. Other problems had to be overcome, such as our diver trying to see through the limited visibility of waters supersaturated with glacial silt.

Oh, they had moved the *Islander* all right, two miles horizontally and 350 feet vertically! And not an inch of it had been easy. There had been the problem of getting lift cables under her in the first place. There had been no deep sea salvage like this before, said the experts. But the crew under Frank Curtis had done it.

As the *Islander's* hulk began to appear above the water at 7:25 a.m. on the morning of July 16, 1934, it appeared that a victory had been won over the sea. But more work was yet to be done—the hulk was covered with debris, mud, and barnacles.

"Looks like dirty work ahead through all that damned mess!" Frank Curtis gripped a nearby timber of the truss as if to hang on for support while Perm, Russell Clithero, Blair Hetrick, and I were looking at the recovered ship. Leaning on his cane to relieve his injured leg, Curtis was talking of the cleanup job yet to be done to remove the tons of mud and wreckage from the *Islander's* hull.

The lifting and moving job was accomplished. Doubting Thomases who had said it couldn't be done were silenced. A Seattle-Portland house mover and his crew had done it. It was the deepest underwater recovery of a ship accomplished to date. And here, on this peaceful but muddy beach of southeast Alaska ringed by a virgin forest, the autopsy was to be performed. Now that Curtis and the crew had the remains of this once-famous flagship, what would they find?

"Where's the gold?" the blunt question came from approaching Dick Kohler.

"We're going to have to dig for it, looks like!" Perm responded.

"How's the pump fixed for the water supply?" Frank wanted to know.

"She's okay, just as long as we have coal for the steam donkey pump and it doesn't go bust on us," Blair commented.

"Well, I think we might have a fresh supply of coal down there," Kohler said, pointing to the *Islander's* hulk at the point where the bow had torn off.

And he was right: the fractured bunkers held a sufficient supply of Nanaimo coal after almost 33 years under water. It would be used to run the pump that was necessary in the sluicing and panning process to recover any gold left in the wreck.

CHAPTER FOURTEEN

THE UNVEILING:
FIRST CLOSE-UP SIGHT
OF THE **ISLANDER**.

"The Unveiling"
First sight of Islander
©1934 Leonard Delano
#118

Sunken Klondike Gold

Piles of barnacles and debris line the sides of the salvage hulk.

Chapter Fourteen

Where the bow broke off.

The Last Signal
©1934 Delano
Salvage Photo 180

What were the salvors after? The answer: some of that Klondike gold, of course. Three million dollars' worth had been reputed to be aboard the ship. How would they get it after that long stay under 350 feet of cold Alaskan water? The answer was prompted by Frank Curtis.

"Get hold of it with cables and lift it with the power of the tides and a lift ship," he said. For the grand finale they would use two lift ships and put it on the beach. The story of the salvaging and events leading up to it could be typed with dots, dashes, exclamation points, and even a few asterisks. It hadn't been simple, but the telling could be worthy of the best Alaskan yarn spinner.

The recovery of the wreck was a dramatic chapter in the story of one of the North Pacific steamships—a story of the men who preceded her, sailed her, and now raised her. The waters

FRANK CURTIS POINTS TO THE ENGINE ROOM TELEGRAPH, WHICH INDICATES THE FINAL SIGNAL ACKNOWLEDGED BY THE **ISLANDER'S** ENGINEER WAS **STOP**. NOTE THE OOZE OF ALMOST A THIRD OF A CENTURY COATING THE ROOM.

that had swallowed her were now quietly receding as if to say, "You have won! You can have her!" But at the same time, the soft lapping was saying, "But some of my secrets you will never get."

As he leaned on the rail of the salvage ship *Griffson,* Curtis's thoughts flashed back to the events leading to this moment. "Damn! They hadn't been easy."

. . .

STEEL BOXES IN ANTICIPATION OF TREASURE. RUMORS OF POSSIBLE HIJACKING PROMPTED SEVERAL SECURITY MEASURES.

Sunken Klondike Gold

The mess of barnacles and debris had to be removed. The man in the light shirt searches for the purser's safe.

Chapter Fifteen

The *Islander* Is Up!

"The northern lights have seen queer sights..."

This line from Robert Service's "The Cremation of Sam McGee" could aptly apply to the steamship *Islander* and its resurrection from the glacier-fed waters of Stephens Passage. Like the Aurora Borealis itself, the trim little steamship had flashed across the horizon in the North Pacific for a brief moment in time. Since sliding down the ways in Glasgow, Scotland, her vibrant hull had touched the lives of many.

She had been a proud ship, small compared to ships of later years but big for those of her time. To those who had known her, from John Irving who had ordered her construction to the many who had felt the throb of her efficient engines beneath their feet, she had impressed them.

Like an animate thing, a ship takes on a character and a personality, and its loss is an emotional experience to those whose lives it had touched. To us in the salvage crew, its dripping carcass was a far cry from the photos we had seen of her in happier days. Like the *Titanic* her steel hull and bulkheads had been touted as unsinkable, though different in state of the art and size. But steel has a way of peeling like a tin can when steered at speeds against unyielding rocks or ice.

Gold reputed to be her cargo was scattered in the muddy debris. Originally wrested with pick and shovel and sluiced and panned by Klondikers from reluctant hills and creeks, it would have to be sluiced and panned again if we were to get it. Ironically, the coal in the holds of the *Islander* would power the pumps for water to sluice and glean her recumbent hull.

But first some of the jumbled wreckage on deck had to be removed. The funnels had gone overboard, but their bases and the remains of certain metal walls and collapsed superstructure had to be lifted out of the way.

That the boilers had not exploded as they might have—the contention of several survivors—seemed to be the case as we began to dig. George MacDougall, a Portland patent lawyer and survivor of the *Islander* wreck, had said that if the boilers had blown as expected she would have split apart. He had claimed, as had others, that the cloud of debris noticed by those leaving on boats and rafts was really a sudden rush of steam.

A jumble of metal from the base of the stacks and upper works was piled atop the barnacle-covered debris. Wiley's clamshell method of attempting salvage no doubt hadn't helped conditions. The wooden superstructure had been gone for some time.

When the approximate location of the purser's safe was placed just aft amidships under a mound of debris, further exploration of that area was put out of bounds. Norton Clapp, who had arrived just before the beaching, seized a shovel to personally inspect the find. His search uncovered the safe under the rubble. Approximately $6000 was found in it, left in the mad scramble of the sinking.

That the *Islander's* safe was almost empty had been the contention of Purser Harry Bishop. It wasn't empty, but it didn't have pokes of gold in it. Instead, they were elsewhere in the ship. And the express boxes and pokes in the strong room—where had they gone? The salvors' efforts were based on the existence of at least some of them or their equal, as claimed by the six men who had helped with loading the gold and swore of its existence.

Looking at the crumpled mass of what used to be the foundation of the cabin structure, we could see that the contents of any strong room could easily have gone overboard after the room's collapse. Also, and probably most likely, the not-too-selective digs of Wiley's clamshell in the dark previous to the Curtis salvaging sent considerable material into the mud alongside the *Islander's* original resting place. Irony indeed after so much effort!

Chapter Fifteen

Uncovering the safe.

It was in early August when most of the cleanup work was done. In the warm weather the huge mass of barnacles and sea critters scattered on the deck of the *Islander* hulk began to smell, and smell with a pungency that did more than just tickle the nose. Working on this phase of the salvage was like prowling on a huge garbage dump, most of which smelled like rotting fish.

Nevertheless, the objective was to find gold, wherever it was, and dead barnacles and mud were minor inconveniences compared to what we had already been through. Coal from the *Islander's* bunkers added to our supply kept the water pumps operating. Hoses were filled with water from the pumps and used to clean the deck and interior of the hull and to operate the sluice boxes. In the latter the final gleaning of the scattered gold was done.

Though it was a mess to work in, the warm weather also helped make the working conditions more acceptable.

FRANK CURTIS (LEFT) AND
DICK KOHLER AT THE SAFE.

Perhaps the water spraying from the hoses was compensation for the mess under the warm August sun. As one of the men said, "I was tempted a number of times to turn the hose on the other guys too."

But dressed in boots and tin pants, these "miners" were on serious business, and they could be grateful for the summer sun instead of the biting Taku winds.

Inasmuch as the elusive gold could be in a number of places, the seekers were on the alert for any hiding place where Fate could have put it. The strong room was gone, but the weight of the gold helped determine its resting spots. Interestingly enough, had a chunk of debris from above not blocked the urinal, some gold might easily have disappeared down the drain before we ever beached the ship. But what about the other pokes?

When the beaching had been accomplished and the search narrowed to combing the debris, the matter of security and news blackouts became a concern to the principals of the salvage organization. An order went out to quarantine all crew members during the cleanup and keep them aboard until the job was done.

The quarantine was effective only for a short time. News of the beaching had become public property and dozens of small boats with curious sightseers from Juneau came to view the *Islander* from a distance. I obtained the use of our "river" boat and an outboard motor, and at 2:00 one morning I headed alone for Juneau to mail some photos and news dispatches.

The summer nights are brief in southeast Alaska, and with the clear sky the visibility was like the savoring of a rare wine. Some early mists curled along the winding edges of the Passage and of Gastineau Channel. Occasionally a salmon leaped out of the water, and in the distance a big whale surfaced and disappeared again. What made the trip more memorable, as I recalled it years later, was the unusual sight that appeared from the mists of Stephens Passage to the south: a long procession of U.S. Navy ships heading for Juneau. The flotilla consisted of a destroyer, a sub tender, several submarines, and other craft that were touring Alaskan waters. The procession passed my little boat, leaving it bobbing in the wake. I reached Juneau as the sailors were completing their anchoring and tying up. The ships' arrival, coming as it did with the recovery of the *Islander,* seemed to me a celebration of the event. It seemed an appropriate coincidence.

SUNKEN KLONDIKE GOLD

CLEANING CREWS CLEAR A DOOR IN ONE OF THE BULKHEADS. TIMBERS ARE KEPT IN PLACE TO PREVENT SALVAGE SHIPS FROM CAPSIZING ON THE **ISLANDER**.

Another reconnaissance group on a training mission had landed at the cow-pasture airport north of Juneau. It was a small group of U.S. Air Force bombers under the command of Colonel Arnold en route from Alaska's interior to the base south of Seattle. With his permission I sent via one of the pilots a packet of news material and photos for mailing in Seattle, saving more than a week in transmission. (Incidentally, two years later a modern airport was built in that area, first used by Pacific Alaska Airways, which finally provided aerial linkage to the Outside.)

The effect of almost 33 years under deep salt water revealed interesting results. Irish table linens that had been folded and stored in linen closets were eaten around the edges by sea worms of some type and reduced to handkerchief-size remnants. But wow—the smell on first recovery from the debris! The sulfur dioxide smell like rotten eggs didn't encourage our saving the linen. After several thorough washings and airings, however, they were like regular linen in appearance, smell, and feel.

All that remained of a carpenter's plane was the wood; the steel was gone, leaving a rust streak. Leather survived, including shoes whose nails and thread were gone, and a dog harness with the bones of an ill-fated dog in it. Records had shown that Fred Rekate of Portland was returning from the Klondike with his favorite sled and pack dog. Were these remains his dog?

Remains of old cameras with their corrosion-encrusted lenses and shutters, even one with the lens board and part of the track and lenses, were found. A tripod with toredo worm holes through it was in the same pile. Who was the photographer? Was he one of the ship's officers or an itinerant shutter-snapper or photo pioneer in the manner of Hegg, the well-known lensman of the 1898 and 1899 years?

As we removed the huge collection of debris, sediment, and barnacles with hoses and various tools, one area uncovered was the liquor locker. A large pile of bottles was what was left of such an important item to the returning Klondikers and southbound Northlanders, an instrument of hospitality and a companion to the fine dining for which the *Islander* was famous.

The eyes of Shorty Curtis, my roommate, sparkled when he recovered the bottles. What was still drinkable was the champagne whose flanked corks had resisted the pressure of approximately 150 pounds per square inch. I can vouch for Shorty, who said the champagne was still good. Corks from sherry and other wines were quite good in resisting the pressure, but wine laced with even a small amount of salt water has a certain racy taste. Even so, desperate men can overlook some things, within limitations.

Kerosene lamps were recovered and cleaned, and when their contents were tested the wicks burned with a subdued but persistent light. Some teapots and dishes—those fragile things—amazingly survived with scars, though many were smashed. I uncovered a large curved stem pipe with the smell of tobacco still powerfully strong. Certain hardwoods survived intact. Recovered banisters from stairways were in excellent condition.

In the rapid sinking of the *Islander*, the question of the stowaways trapped in the bunkers of the bow section always seemed to bear a special tie to some of the unanswered questions of this marine disaster. And the fact that the bow section broke off during the lift and lay at the bottom of the Passage leaves some questions still.

Testimony at the Inquiry brought out that there were 11 stowaways. Fireman Stuart of the *Islander* crew revealed that he had let one stowaway out a hatch when he heard muffled cries for help. But there seemed to be no further information on the other 10 at that time. In the news reports little or nothing was mentioned of the stowaways, and they were not counted in the official report of lives lost.

How many skeletons are in the bow section as it lay at the bottom of the Passage? What was the extent of the damage portside of the bow as the result of the collision that caused the sinking? Perhaps the second question, if answered, could help bring to a conclusion the controversy of the iceberg versus Pt. Hilda that the *Islander* struck.

CHAPTER FIFTEEN

THE FINAL CLEANING PROCESS. TRUSS LOGS HAVE BEEN REMOVED.

Sunken Klondike Gold

The biggest gold find was in this urinal; presumably, a broken leather poke had dropped from the deck above.

146

CHAPTER FIFTEEN

A CORNER WHERE SOME GOLD WAS FOUND, WITH SOME DEBRIS YET TO BE REMOVED.

SUNKEN KLONDIKE GOLD

*Panning Islander Gold
©1934 Leonard Delano
Salvage Photo No. 210*

MIKE KELLY PANS FOR GOLD WITH GOOD RESULTS.

CHAPTER FIFTEEN

SLUICING THE DEBRIS BY HAND WAS PART OF THE GOLD RECOVERY PROCESS.

Bits of barnacles in the sluice box mingle with the yellow stuff.

Chapter Fifteen

Gold in the CPN chamber pot.

SUNKEN KLONDIKE GOLD

THE AUTHOR GETS COAL FROM THE **ISLANDER** TO FIRE THE STEAM PUMP FOR SLUICING OPERATIONS.

Chapter Fifteen

ONE OF THE **ISLANDER'S** ENGINES AND A SALVAGE CREW MEMBER.

SUNKEN KLONDIKE GOLD

PROPELLERS THAT ONCE DROVE THE SHIP. THE CUTTING LINE THAT SWEPT UNDER THE SUNKEN SHIP NICKED A PROPELLER AND TORE OFF THE RUDDER.

CHAPTER FIFTEEN

RECOVERED ITEMS INCLUDE THE WOODEN FRAME OF A CARPENTER'S PLANE, KEROSENE LAMP, AND SILK FABRIC.

155

SUNKEN KLONDIKE GOLD

A DOG WITH A HARNESS WAS ONE OF THE PASSENGERS. COULD IT HAVE BEEN FRED REKATE'S DOG?

Chapter Fifteen

Camera lenses recovered.

Some remains of the liquor stores.

157

SUNKEN KLONDIKE GOLD

TEAPOT, SALT AND PEPPER SHAKERS, PIPE,
POCKET WATCH, NAPKIN, IMPLEMENTS.

DINNER PLATE AND SAUCER,
NAPKIN, SILVERWARE.

Leonard Delano Photo

CHAPTER FIFTEEN

Leonard Delano Photo

NAMEPLATE, SHIP'S BELL, AND LEATHER BOOT.

159

Epilogue

After the conclusion of the salvage operations, I returned to Juneau in the hope that Alaska held prospects for this and other stories. Making a living included a depression-style mixture of some photojournalism, a period of working in the Alaska-Juneau Mine mill, and some motion picture assignments.

The upper Gastineau Channel waterfront at that time included a cluster of run-down houses for the main group of Tlingit coastal Indians in the area. The main wharves and seaplane landing area were centered farther west at the main center of town. It was between these two areas that I met Tukluk John—at least that was my understanding of his name. He was rowing a battered rowboat carrying some fishing gear and had an old pipe between what was left of his teeth.

Apparently he had more gear to get. As he pulled alongside and threw the tie-down rope on the dock, I felt obliged to assist and threw a couple of half-hitches with it around a piling.

Noticing my old Graflex camera, he pointed to it. "Taking pictures?" he asked.

"Just looking around," I replied.

"You take *Islander* pictures too?" he asked in more of a statement than a question. He had obviously been told of my stay on the salvage ship and who I was; in a small town every word goes from one group to another.

I confirmed that I had; in the course of our brief conversation, he seemed to be communicative and finally asked to see some of the photos. I agreed to show some a couple of days later. The story he then told me was a strange and startling revelation of another *Islander* tale.

John was in his late forties and at the time of the *Islander* sinking had been about eight years old. When news of the sinking reached the towns of Douglas and Juneau and spread to adjoining areas, it also traveled to the Indians of the area. His father and several others headed for the shore of Douglas Island adjacent to the disaster.

John hesitatingly told of his father later coming back to their home. His father told of stopping at a deserted storage shack in the fog-draped early morning hours. But he hadn't been alone. He had helped two survivors he had found on the beach, had brought them to the shack, and had revived them with a fire; he and a companion then had obtained some coffee and food for them. One was a stowaway and the other was a regular passenger. From what I could understand, the surviving stowaway was one of the two who had escaped.

In the testimony at the Inquiry at Victoria, Fireman Stuart revealed how he had released one stowaway through a hatch the night of the sinking. What he apparently didn't know was that two more stowaways had escaped out that hatch in the darkness and confusion and jumped overboard just before the ship went under. An explosive release of air and steam scattered wreckage over the area as she went down, and presumably the two managed to cling precariously to a piece of the wreckage.

One drowned in that cold dark period before dawn, but a lifeboat picked up the other and deposited him more dead than alive with another survivor, then returned to search for others. It sounded like the stowaway had something to do with saving the other survivor.

John's father never remembered the two survivors' names, if he ever knew them. But as John explained, his father "fixed them up" and helped dry their clothes, and they left in a few hours.

"Did they have anything with them?" I asked.

"Oh yes. They have small heavy sack, like leather sack," he said.

That, I thought, could have been a poke of gold.

· · · · ·

What has happened in the years following the *Islander's* salvaging? Consideration of raising the bow was soon wisely discarded as being financially impractical and an exercise in futility. Some thought it might be the repository of the missing millions but were quickly overruled. After all, if the *Islander* sank so quickly because of damage to her bow section, it must have left a monstrous hole through which the bow's contents would spill.

And when the bow, while nosed into the muddy bottom of the Passage, was wrenched by the first lifts, the fractures on her port side undoubtedly spread. If the bow was carried very far in the lifting process, it may have lost even more of its contents.

In 1941 Curtis and his men raised the dredge *Natoma* at Astoria, Oregon, using hand-ratcheted winches. In 1942 they used the same winches to raise a seagoing tug at Alameda in the San Francisco Bay region. The tug, with a shipment of torpedoes aboard, presented a ticklish problem; using ingenuity and persistence, Curtis and his crew succeeded and tug and torpedoes were recovered. The winches were used in other lift work at the Mare Island shipyard, also in the Bay region.

Final disposition of most of the lift winches was made when they were purchased by Fred Devine and Art Zimmerman of Portland. Here they were used with other salvage equipment on the Columbia River and along the Pacific coast in connection with the tug *Salvage King*.

Hydraulic controls have sometimes replaced the manually operated handles for turning the drums. In 1978 a Port of Portland dredge was raised using 12 winches equipped with Schrader Recipropac air cylinders. Captain Reino Katilla, J. M. Leitz, and others who have carried on since Devine's death can attest to their usefulness. They are now stored at the Devine headquarters on Swan Island in the Willamette River in Portland, ready for salvage emergencies.

Two items of interest occurred in 1952. In June the tug *Donna Foss* towed a barge loaded with rusted scrap up the Duwamish River in Seattle. It was the remains of the *Islander* left on the beach in 1934. She had finally made her last voyage. The second was the death of Frank Curtis at the age of 67. He didn't get the storied millions, but he and his crew set a world's record for their day.

Glossary

aft: Near or toward the back of a ship

barkentine: A sailing ship with three to five masts of which only the foremast is square rigged, the others being fore-and-aft rigged.

bow: Forward part of a ship

cable line: Thick line of rope, strands of metal wire, or chain for towing, mooring, or securing a ship.

cucumber: Nickname given the cutting tool made in Seattle

cutting line: Length of heavy chain positioned on a lift cable and running under the Islander to cut through the accumulated sediment around the hulk

davit: Small crane on a ship, especially one of a pair for lowering a lifeboat.

doggo stowaways (Brit. informal): Remain motionless and quiet to escape detection

fathom: Unit of length equal to six feet for measuring the depth of water, rope, or cable.

foc'sle, forecastle: Upper deck of a ship in front of the foremast; the front part of a merchant ship where the sailors' quarters are located.

fore: Toward the front of a ship

hurricane deck: A covered deck at or near the top of a ship's superstructure.

kedge: Small anchor used in warping a ship or steering it when ashore

lift cable: Steel cable placed from the winches on the lift ships

poke: Sack, bag, or pocket.

port: Left side of a ship perceived by a person on board facing the bow

scow: Large, flat-bottomed boat with square ends used for carrying freight; generally towed by a tug.

starboard: Right side of a ship perceived by a person on board facing the bow

steam donkey: Steam-powered winch widely used in logging and maritime industries to provide a power winch

stern: Back part of a ship

taffrail: Around the stern of a ship

warp: to move (a ship) by hauling on a rope attached to a stationary object ashore

CANADIAN PACIFIC NAVIGATION COMPANY INSIGNIA ON THE *ISLANDER* CHINA

Sunken Klondike Gold

Index

Page numbers for photographs are in **bold**

—A—
Admiralty Island, 19, 101–102
Akutan, 74
Alaska communications system (WAMCATS), 82, 91–92
Alaska Pacific Express, 32
Allen, George, 19
Andrews, C.L., 13
Ashton, Edgar, 19, 20

—B—
Banta, Gerald (Gary), 51, 52–54
Beloit, 57, 59–60
Bennett, M.E., 36
Bishop, Harry, 9, 138
Blessener, Leo, 51, 79
Bremerton, 54, 84
Brown, George McL., 31
Brownfield, J.C., 51, 60, 63, 84, 87, 88, 100–101, 109, 112–113, 114, **56**
Brownlie, Chief Engineer, 19
Busby, George, 51, 74, 84

—C—
Canadian Bank of Commerce, 32
Canadian Klondike Mining Co., 36
Canadian Pacific Navigation Company, 3–8, 31–32, 35
Canadian Pacific Railroad, 7–8
Carcross, Yukon Territory, 13
Chilkoot Pass, 11
Clapp, Norton, 45–48, 138
Clithero, Al, 51
Clithero, Cliff, 62
Clithero, George, 39
Clithero, Irvington, 78, 111
Clithero, Ray, 51
Clithero, Russell, 44, 49, 54, 62, 63, 65, 67, 100
Close Brothers, 13
Coal supply, 130, **152**
Coast Guard, 117, **120**
Curry, Nick, 111
Curtis, Frank, 39–41, 45–48, 49, 60, 67–68, 87, 94, 109, 129–130, 163, **46, 47, 90, 134, 140**

Curtis, Ross, 109, **121**
Curtis, Shorty, 49, 109, 144, **90, 121**
Curtis–Wiley Marine Salvors, Inc., 40, 41

—D—
Dalton Trail, 36
Danube, 6
Dawson, Yukon Territory, 13
Delano, Leonard H., ix, 39–162, 166, **152**
Diving bells, 39, 63–66, 41, 58, 61, 62, 66
Dixon, Jane, 1
Donkey engines, 63, 71–73
Donna Foss, 163
Douglas Island, viii, 17–19, 29, **17**
Dumbolton, J.C., 36
Duncan, Dr., 25–26, 28

—E—
Elizabeth Irving, 3
Engine room telegraph, 134

—F—
Ferry, George, 18, 19, 20
Finch, Henry, 32–35
Foote, H.R., 6, 9, 18–19, 23, 27
Forest Pride, 109–114, 115
Fowler, Horace, 13, 22
Frary, Dick, 101
Friend, Elmer, 91
Funeral at Juneau, **30**

—G—
Garfield, Kelly, 87, 89
Georgia, 51–57, 73–75, 109–114, 55, 57
Gill, Lester, 23
Gillispie, Robert, 41
Gjarde, Peter, 41
Glenn, John S., 36
Gold:
 amount on board, 31–32, 36–38
 recovery of, 134–135, 137–152, **146, 147, 148, 149, 150, 151**
Goss, Josiah, 6
Green Cove, viii, 95, 129–159, 17
Griffson, 42, 49–58, 105, 114, **43, 44, 50, 54, 69, 90**
Guarding the find, **135**

—H—
Hansen, A.E., 41
Harris, Charles, 20, 37
Hayes, Charley, 51, 57, 63, 65–66, 67, 70, 87, 92, 108, 58, 90
Hellene, Sigard (Si), 51, 68, 71, **70**
Heney, Mike, 13
Henry Finch, 31–35
Herbert, William S., 36
Hetrick, Blair, 51, 68, **70, 86**
Huckins, Charley, 104–105, 115–117, 124, **116, 117**
Hudson's Bay Line, 3
Hughes, Ernest, 87
Hughes, Jim, 111
Hurlburt, Slim, 51

—I—
Ice, 18, 103–104
Irving, John, 1–7, 13, **4**
Irving, William, 1–3, **x**
Irvington, 1
Islander:
 at dock in Skagway, **10**
 crew, viii
 construction of, 4
 description of, 6
 early voyages, 6–7
 final trip from Skagway, 9–29
 life belt from, **24**
 passengers of, viii
 photographs of interior, **11–12**
 plans of, **5**
 recovery of, viii–ix
 sinking, viii, 17–29
 specifications, 4
 underway from Victoria, B.C., **14**

—J—
Jackson, Frank, 41
Johnson, Capt., 31
Johnson, Clifford, 51, 54, 60, 66, **64, 90**

—K—
Kashavaroff, Fr., **24**
Kattila, Reino, 163
Kelly, Mike, **148**
Ketchikan, 56, 114

INDEX

King, Harry, 111
Klondike gold rush, 7, 9–13
Knapland, Carstine, 57, 59, 111
Knapland, John, 57, 59
Kohler, Dick, 49, 51, 62, 99, 130, **90, 140**

—L—
Lake Union, 49–51, 109–111
LeBlanc, Pilot, 17–18
Leitz, J.M., 163
Lift structure, **126**
Lindley, Bill, 111
Livingstone, Capt., 73–75
Lloyd's of London, 32
Logging and logs, 118–119, **122, 123, 124, 125**
Lorna Foss, 84
Lynn Canal, vii

—M—
McAlister, C.C., 51, 111
McCormick, A.E., 36
McDonald, H.H., 22
MacDougall, George, 138
MacFarlane, Joseph, 23–28
Mattson, John, 87
Meyer, William, 6
Moore, Billy, 13
Moore, John, 31
Morris, H.H., 32
Munro, Jan, 3

—N—
Napier, Shanks and Bell, shipbuilders, 4
Navarre, Richey, 111
Neroutsos, First Officer, 18–19, 20, 22
New Westminster, B.C., 2–3
Newspaper accounts of sinking, 22, 29, 21
Norco, 77–78, 81, 77
North Light, 83–84
Northwestern, 73–75

—O—
Olmstead, Dave, 51, 60, 94–95
Olmstead, Larry, 51
Olsen, Ernest, 51
Onward, 3
Oregon City, 1

—P—
Palmer, Claude, 44–45
Peterson, Ernie, 51
Phillips, A.W., 20
Photo equipment, 45
Pioneer Line, 3
Point Hilda, viii, 17, **17**
Portland, 1
Port Moody, B.C., 7
Powell, George, 9, 18, 20
Preston, Walter, 21
Purser's safe, 138, **136, 139, 140**

—Q—
Queen Charlotte Sound, 54

—R—
Redline, Capt. 6
Richmond Beach, 51
Rithet, 3
Rithet, R.P., 3–4
Robbins, Willard, 51
Robertson, George, 4
Roosevelt, Franklin, 42, 44–45
Rose, George, 51, 63, 74, 84
Ross, Mrs., 25–26, 28, 29
Rudlin, George, 6

—S—
Salvage:
 accidents, 68–70, 81, 88, **80**
 after raising, 129–159, **131, 132, 142, 145, 153, 154**
 crew, **53, 110**
 depth, 32
 early efforts, 31–35, 138
 lifting the ship, 41–42, 71–78, 79–90, 93–105, **69, 83, 85, 119, 126**
 locating the ship, 40, 59–65, **42**
 loss of the bow, 93, 96, 99, 105, **133**
 on the beach, **128**
 record effort, 129
 scrap, 163
Salvage King, 163
Salvaged objects, **iv, vi, 155–160**
Sandberg, Frank, 51
Seymour Narrows, 52–54

Shaver, George W., 2
Simons, Ed, 51
Skagway, 9–13
Sparrows, Bert, 36
Starling, 51
Stephens Passage, viii, 17–18, 35, 57, 75–76, 141, **17**
Stowaways, 15–16, 19, 144, 162
Stuart, Jon, 19
Stuart, Murray, 105
Success, 1

—T—
Triple, Dick, 51
Troup, James, 8, 31
Troup, W.H., 8
Tukluk John, 161
Turnbull, James, 8

—U—
Undine, 51, 54, 60, 62, 107–108, **106**

—V—
Vanderbilt Reef, 73

—W—
Waddell, Perm, 49, 68, 71, 109
Wahlborg, John, **46, 47**
Walbran, J.T., 6
Walker, Inspector, 21–22
Ward, Charles, 18
Warren, Will, 51
Wells Fargo Express Co., 36
Weyerhaeuser kidnapping, 112–113
Whitehorse, Yukon Territory, 13
White Pass and Yukon Railroad, 11–13, 36, 37
Wiley, Carl, 39–42, 138, **42**
William Irving house, **2**
Williams, Lewie, 39, 41

—Y—
Young, Edward, 20
Young Iron Works, 42
Yukon, 34–35
Yukon Gold Co., 36

165

About the Author

Leonard H. Delano was born in Seattle, Washington, on August 30, 1908; except for four years in Alaska (including two years with the *Islander* raising), he lived in Oregon. While in Alaska he worked as a motion picture cameraman for the 1938 movie *Call of the Yukon*. After returning to Oregon, he did newsreel work using a 35mm motion picture camera and worked as a reporter for the *Oregonian* and the *Oregon Journal*.

Leonard attended Benson Tech High School in Portland and was a member of the University of Oregon class of 1930, majoring in geology and journalism. He began working for Brubaker Aerial Surveys while learning photogrammetry. He eventually bought the company as well as several other photographic businesses, all operating as Delano Photographics and Western Mapping Company in Portland. He retired in 1983 after working 48 years in commercial photography and photogrammetric mapping. He accumulated a large collection of historical photographs and continued to be interested in the Geological Society of the Oregon Country. Often he was asked to speak on illustrated geology subjects for this and other groups.

Leonard was a member of the American Society for Photogrammetry and Remote Sensing, the Photographers Association of America, the Society of Photo-Optical Instrumentation Engineers, and the Masonic Lodge. The father of two boys, Leonard often shared with them stories of his adventure in Alaska. He died in 1989 without realizing his dream of publishing his account of the *Islander's* raising.